Christopher Lloyd

FRA ANGELICO

PHAIDON

For H.W.J.M.L. and S.L.

Phaidon Press Limited, Littlegate House, St Ebbe's Street, Oxford

Published in the United States of America by E. P. Dutton, New York

First published 1979

© *1979 by Phaidon Press Limited*

ISBN 0 7148 1997 2
Library of Congress Catalog Card Number: 79-88174

Printed in Great Britain by Morrison & Gibb Ltd, Edinburgh

Fra Angelico

Fra Angelico is one of those unfortunate artists who have become prisoners of their own reputation. Beginning with Giorgio Vasari, and extending right up to the present day, there has been a tendency to exaggerate his links with the monastic world. Thus Vasari, in his *Lives of the Most Eminent Painters, Sculptors, and Architects*, after a careful account of Fra Angelico's works, concludes his biography of the artist with an analysis of his character:

> Fra Giovanni was a man of the utmost simplicity of intention, and was most holy in every act of his life. . . . He laboured continually at his paintings [and] used frequently to say, that he who practised the art of painting had need of quiet, and should live without cares or anxious thoughts. . . . It was the custom of Fra Giovanni to abstain from retouching or improving any painting once finished. He altered nothing, but left all as it was done the first time, believing, as he said, that such was the will of God. It is also affirmed that he would never take the pencil in hand until he had first offered a prayer. He is said never to have painted a Crucifix without tears streaming from his eyes, and in the countenance and attitudes of his figures it is easy to perceive proof of his sincerity, his goodness, and the depth of his devotion to the religion of Christ.

Vasari here directly equates the strength of Fra Angelico's religious conviction with his ability as a painter, implying that in some indefinable way the quality of his paintings was related to his mode of living.

In the nineteenth century, with the revival of interest in early Italian painting, Vasari's characterization of Fra Angelico assumed almost gigantic proportions. Writers such as Lord Lindsay in *Sketches of the History of Christian Art* (1847) and Alexis-François Rio in *De l'Art Chrétien* (1861) adopted a quasi-mystical approach to Italian primitive painting in general and to Fra Angelico in particular. This approach reaches a climax in a book entitled *Art Studies* (1861) written by the American collector James Jackson Jarves, who declared that 'Fra Angelico is the St. John of art.' This adulation was not just a literary indulgence; it had a practical outlet as well during the nineteenth century. When the German Nazarene painters – those intrepid precursors of the Pre-Raphaelites – settled in Rome in 1810, they were known as the Brotherhood of St Luke and took up residence in the monastery of Sant'Isidoro, thereby emulating Fra Angelico, in whose paintings they saw a perfect fusion of the Ideal with Nature. On a more urbane level, but equally revealing, is an anecdote recorded in the *Journals* (1895) of Lady Eastlake, the wife of Sir Charles Eastlake, the first Director of the National Gallery in London. When, in August 1858, the Eastlakes took a painting ascribed to Fra Angelico to be examined in Milan by the famous restorer and Keeper of the Brera Gallery, Giuseppe Molteni, they were told: 'Fra Angelico was an angel, I am but a man.'

It is true to say that anyone today who looks at Fra Angelico's paintings does so as heir to this purely emotional response. Yet it needs to be emphasized that Fra Angelico's supreme qualities as a painter stem more from his mastery of style than from the sanctity of the subject-matter. With this in mind it is necessary first to

summarize the main events of his life before examining the works of art themselves.

The artist's real name was Guido di Piero di Gino, although after his religious profession he was called simply Fra Giovanni da Fiesole. He was born in the Mugello, an area to the north-east of Florence near Vicchio. The exact date of birth is not known, but Vasari mistakenly asserted that Fra Angelico was 68 when he died in Rome in 1455, thus implying a birth date of 1387. While the date and place of death are indeed correct, the age at which the painter is supposed to have died is erroneous. This vital error was compounded by another of more recent origin, namely that Fra Angelico took the habit in 1407. It has now been shown that he was still a layman in 1417, and not until 1423 is he referred to as a friar. Fra Angelico therefore seems to have joined the Dominican community at Fiesole sometime between 1417 and 1421, allowing two years for his profession. Interestingly, the document of 1417 already refers to him as a painter and concerns the advancement of his name by the miniaturist Battista di Biagio Sanguigni for membership of the Compagnia di San Niccolò in the church of Santa Maria del Carmine in Florence. All this indicates that Fra Angelico was probably born around 1400, and the revision of this essential date means that he belonged to the same generation as Masaccio, as opposed to that of Masolino. This, as will be seen, is of some significance when considering Fra Angelico's role in the evolution of Florentine painting.

The other documents in which Fra Angelico is mentioned provide information about two spheres of his life. Firstly, they refer to his career within the Dominican Order. The Order was at this time expanding in Tuscany as a result of a reform movement initiated at the end of the fourteenth century and known as the Dominican Observance. The teaching of the Dominican Observants by such distinguished minds as those of Giovanni Dominici and Antonino Pierozzi, later Archbishop of Florence, was to exercise a powerful influence over Fra Angelico's paintings. Indeed, a late painting of *Christ on the Cross with the Virgin and St John the Evangelist adored by a Dominican Cardinal* (Plate 48) evokes a meditative calm that can be readily compared with the writings of Giovanni Dominici, Antonino Pierozzi, and the Spanish Cardinal Juan de Torquemada, who has been identified as the cardinal depicted on this panel kneeling at the foot of the cross.

Fra Angelico is first recorded as a friar in 1423 in the convent of San Domenico at Fiesole. Here he held office as Vicario, remaining in Fiesole after 1435 when a number of the monks had moved into the city of Florence, eventually to establish themselves in the convent of San Marco. The painter himself did not move to San Marco, the place so widely associated with his name, until after a lapse of a few years; he is, in fact, first recorded there in 1441. Again, in the larger convent of San Marco, he held office, this time as *sindicho*, which appears to have been a post with some financial responsibilities. The architect of the new buildings at San Marco was Michelozzo, one of the finest and most modish exponents of Brunelleschi's architectural principles. Fra Angelico's work in the convent included the painting of the high altarpiece in the church (Plate 24) and the decoration of the cells, cloisters and corridors (Plates 28–31). These works, especially the frescoes in the cells, cloisters and corridors, served a particular purpose within the monastic community, and they were painted in an advanced style that exploited both the requirements of the monks and the most recent developments in Florentine art. In 1450 Fra Angelico was appointed Prior of San Domenico at Fiesole, where he succeeded his own brother Fra Benedetto. No doubt it was a combination of his position within the Order and his reputation as

a painter that led to the choice of the main Dominican church in Rome, Santa Maria sopra Minerva, for his burial-place.

The second sphere of Fra Angelico's life illuminated by the documents is his reputation as an artist. He was much in demand even beyond the monastic communities of San Domenico at Fiesole and San Marco in Florence, and we know of commissions and negotiations dating from various decades of his life: in Brescia (1432), Cortona (1438), Orvieto (1447), Prato (1452), and Rome (c. 1445–9 and c. 1453–5). Apart from the works carried out in these places, Fra Angelico is twice recorded acting as an assessor in the valuation of works of art executed by contemporaries. The first occasion was in 1434, together with Rossello di Jacopo Franchi, for an altarpiece painted largely by Bicci di Lorenzo in the church of San Niccolò oltr'Arno. The second occasion was considerably later, in 1454, when it was deemed that frescoes painted in the Palazzo dei Priori in Perugia should be assessed either by Filippo Lippi, Domenico Veneziano, or Fra Angelico. The nomination of such illustrious alternatives indicates the standing that Fra Angelico had in Florentine art.

Of all the opportunities presented to Fra Angelico for working outside Florence, the most prestigious was undoubtedly the invitation to travel to Rome, initially at the behest of Pope Eugenius IV and then of Pope Nicholas V. The papacy was at this time still consolidating its position in Rome and throughout Italy after the Schism. This policy took many forms, but outwardly its most impressive manifestation came in the revival of the arts, exemplified by the restoration of the main churches and the development of the city as a modern urban complex, including the establishment of the Vatican as a permanent papal palace. The policy reached a climax in the Jubilee celebrations of 1450 and found a more permanent expression in the gradual rebuilding of St Peter's and of the Vatican. Each of the Popes concerned (Martin V, Eugenius IV and Nicholas V) attracted a host of artistic talent to Rome, but none more successfully than Pope Nicholas V, who was a considerable scholar in his own right and who was, for example, prepared to pay his translators of classical texts virtually double what he paid Fra Angelico. As at San Marco, so in Rome Fra Angelico was engaged in decorating newly constructed or adapted buildings, and what impresses us today is the speed and efficiency with which he completed these different tasks. Between 1446 and 1449 Fra Angelico painted no fewer than four different fresco cycles in various chapels in the Vatican, only one of which has survived intact (in the Chapel of Pope Nicholas V, otherwise referred to as the Chapel of St Lawrence and St Stephen, Plates 34–38), while one of the others (in the Chapel of the Sacrament) was described by Vasari before its destruction for rebuilding. Fra Angelico's facility is rare even for an age that nurtured such expeditious fresco painters as Benozzo Gozzoli and Domenico Ghirlandaio. In carrying out such an ambitious programme of work, Fra Angelico undoubtedly benefited from an almost faultless technique, but he also had recourse to a number of studio assistants. Of these, Gozzoli was the most distinguished, though in both Rome and Orvieto Fra Angelico used a whole team of helpers. Yet the role of these assistants while they remained in Fra Angelico's workshop was a subordinate one, usually limited to mundane executant duties; the design and the finish remained the master's. The fact that Fra Angelico used assistants, therefore, in no way detracts from his achievements in Rome, and his work there, carried out mainly for Pope Nicholas V, is amongst the earliest of those extensive papal commissions that gradually resulted in the supremacy of the Eternal City over Florence as an artistic centre.

The documents, however, are far less informative about specific paintings. The dates of the fresco cycles are established, principally by detailed records of payments, but only five of the altarpieces can be precisely dated: that for San Pietro Martire in Florence (now in the Museo di San Marco) in 1429; the triptych for the Arte dei Linaiuoli (now in the Museo di San Marco, Plates 10 and 11) in 1433; the *Lamentation over the Dead Christ* for the Confraternità di Santa Maria della Croce al Tempio in Florence (now in the Museo di San Marco) in 1436; the polyptych for San Domenico in Perugia (now in the Galleria Nazionale dell'Umbria, Perugia, Plates 20, 22 and 23) in 1437; and the polyptych for San Domenico, Cortona (now in the Museo Diocesano, Cortona; Plate 21) in 1438. Other works, both in fresco and on panel, have been assigned various dates on the basis of style, but this has led to certain difficulties over the chronology of the painter's œuvre, which is still not a settled matter.

The most important formative influences on Fra Angelico are only referred to indirectly in the documents. Considering his connections with the miniaturist Battista di Biagio Sanguigni, it is hardly surprising that he also painted miniatures at the outset of his career. Many of these, after his profession, were presumably for San Domenico at Fiesole (Plates 2 and 3), and several drawings attributable to him (Plate 1) appear to have been executed on spare pieces of vellum. A document of 1418 refers to a lost altarpiece painted by Fra Angelico for the church of Santo Stefano al Ponte in Florence, where Ambrogio di Baldese, a follower of Orcagna, was employed in decorating the walls of the chapel and had indeed originally been commissioned to paint the altarpiece as well. The juxtaposition of the frescoes by Ambrogio di Baldese with an altarpiece painted by Fra Angelico is not without some significance, since the central panel of Fra Angelico's early altarpiece for San Domenico at Fiesole (Plate 4) bears a striking resemblance, both stylistically and in the facial type of the Virgin, to those few panels now ascribed to Ambrogio di Baldese.

The affiliation of the Compagnia di San Niccolò to the church of Santa Maria del Carmine in Florence is also significant. Certain of Fra Angelico's early works display a knowledge of Masaccio in the solidity of the human frame and in the chiaroscural system of modelling. At first, Fra Angelico reduces the stylistic features derived from Masaccio to a smaller scale, but in his altarpieces one can observe a gradual progression that reveals an increasing confidence in the treatment of spatial intervals. Like his important predecessor Gentile da Fabriano, whose work in Florence and Rome the master must have studied, Fra Angelico's principal achievement was to develop a feeling for the monumental without sacrificing the lyricism inherent in his style. Thus there is a wide range in his œuvre, extending from small, minutely painted, almost bejewelled panels such as *The Last Judgement* (Plate 6) to massive altarpieces like the Linaiuoli triptych, which, with its marble frame and folding wooden shutters designed by Lorenzo Ghiberti, is the largest such altarpiece executed during the fifteenth century and is in many ways directly comparable with sculptural projects (Plates 10 and 11). There is a similar range in Fra Angelico's treatment of narrative. In his predella panels, which, as regards scale and facture, are similar to his manuscript illuminations, one is always struck by the heightened sense of drama contained within a small space. The aged Elizabeth surmounting the steep hill from which one can view the full panoply of the southern Tuscan landscape in *The Visitation* (Plate 8), a predella panel from *The Annunciation* at Cortona (Plate 7), is an unforgettable image, especially if one has oneself climbed the hill to Cortona, a town which Henry

James described as being 'nearer to the sky than to the railway station', in order to see the altarpiece. Similarly, the scenes from the predellas of the Linaiuoli triptych, the Perugia polyptych, or the altarpiece for San Marco (Plates 25–27), abound with vividly depicted passages of narrative painting. This supreme ability, which Fra Angelico shared with his contemporaries Sassetta, Filippo Lippi and Pesellino, was also transferred on to a monumental scale in his frescoes, notably in those in the Chapel of Pope Nicholas V (Plates 34–38). In this combination of the monumental with the lyrical, Fra Angelico epitomizes the achievement of the Early Renaissance. What concerned artists of the first half of the fifteenth century was to depict the world around them with the greatest possible degree of verisimilitude. This concern was not limited to the depiction of the human form, but included the space within which that form moved, so that the setting, as well as the figures, had to be seen to comply with natural laws. Certain theoreticians of the fifteenth century, both mathematicians and painters, believed that a mathematically based system of perspective was the correct way to render the world surrounding them with the greatest possible fidelity to nature. Yet, while this did undoubtedly assist painters, there were other technical devices that could aid them. Fra Angelico himself, for instance, combined in his compositions a system of one-point perspective, usually applied empirically, with his ready skills in the drawing and modelling of the human figure.

Fra Angelico's treatment of space is best demonstrated by an examination of the centre panels of three of his principal altarpieces. On the altarpiece for San Domenico at Fiesole, the main panel of which was originally tripartite, the Virgin and Child sit on a tall throne placed upon a marble base with a curved front jutting out towards the spectator (Plate 4). The Virgin seems to sit on the edge of the throne, whilst the *baldacchino* itself is encircled by angels. Before the throne on the patterned floor kneel two more angels seen in three-quarters profile. In the two later altarpieces, executed for the churches of San Domenico in Perugia (1437) and Cortona (1438), these two angels have been replaced by vases of flowers (Plates 20 and 21), which, though inanimate, are no less effective in defining the sense of distance between the seated Virgin and the spectator. The base of the throne in the Perugian altarpiece (Plate 20) is square, and the angels are more carefully distributed around the Virgin than in the altarpiece at Fiesole (Plate 4). The two angels behind pop their heads round the back of the throne in an almost playful way, while the pair at the front carry baskets of roses. The angel in front on the right confronts the spectator with a direct stare, which reinforces the direction of the Child's gaze. In the altarpieces in Perugia and Cortona the Virgin is more firmly placed on the throne than in the Fiesole altarpiece, but, even when due allowance is made for the damaged state of the Perugian altarpiece, that in Cortona is perhaps the more successful of the two (Plate 21). In this the composition is slightly more orthodox in that the angels are positioned behind the arms of the throne, but the spatial progression from the vases on the floor in the immediate foreground to the back of the altarpiece is more carefully measured. The throne is made of marble. It is square at the top. There are two heads painted in monochrome placed in tondi in the spandrels, and spiral columns with corinthian capitals decorate the sides. The back of the throne is shaped in the form of a curved niche, topped by a round-headed arch with filigree work. The Virgin sits on a piece of patterned drapery that echoes the decoration around the back of the niche. The figure of the Virgin with the Child standing on her left knee

is imposing, the shape of the body being suggested by the folds of the drapery and the puckering of the cloth. There is no ambiguity in the poses of the angels. They are intent upon the task of adoring the Virgin and Child, and, in so doing, set an example to the spectator.

In addition to these three altarpieces, which are strictly traditional in format, there are those in which Fra Angelico has unified the main visual content of the altarpiece on a single panel. These form an impressive series, extending from *The Annunciation* at Cortona (Plate 7), through *The Deposition from the Cross* (Plate 12) and the San Marco altarpiece (Plate 24) to *The Coronation of the Virgin* in the Louvre (Plate 39). The first of these works makes telling use of a simple device for the convincing depiction of space, namely the interlocking of the figures within an architectural setting. The loggia in which the Annunciation takes place is positioned slightly obliquely to the picture plane, so that one side of it is seen receding into the distance towards the back of the picture. This row of arches carries a cornice that leads the eye to the incident in the upper left corner of the altarpiece, which is directly related to the momentous event taking place in the cloistered privacy of the foreground. In the upper left corner Fra Angelico has shown the Angel with the flaming sword expelling Adam and Eve from the Garden of Paradise, an event that is balanced theologically by the Annunciation itself, whereby man is granted the possibility of eventual redemption. God the Father is located in a tondo immediately above the column that separates the Archangel Gabriel from the Virgin. The gaze of God the Father is directed downwards, towards the Virgin. The whole scene is illuminated by light entering the picture apparently from the right. The main incident is bathed in the full glare of this light, which strikes the arches extending backwards in the picture with a similar force. Yet the Expulsion of Adam and Eve is shown with a supernatural light shining from the Garden of Paradise, 'fierce as a comet' in Milton's phrase. It is as though the Angel had suddenly opened a door, thereby emitting bright rays into the surrounding darkness. If, therefore, it is the architectural elements that visually link the subsidiary scene to the Annunciation, it is the two principal figures who reinforce the horizontal axis of the composition as a whole. The Virgin is seated near the right edge. She is seen in three-quarters profile, her arms crossed in a gesture of humility. The book she has been reading rests precariously on her right knee and may slip to the ground at any moment. The Archangel Gabriel stalks into the loggia, the tip of his wings extending as far as the left edge of the panel. The picture space is divided vertically into three parts by the two columns in the foreground. The figures are placed beneath two arches, but neither is completely contained by its respective arch, so that we receive an impression of dramatic movement from left to right. Although *The Annunciation* portrays a private moment, which the spectator is privileged to witness, we are kept at a distance and not admitted to the loggia, being separated from it both physically and psychologically by the columns.

The Deposition from the Cross (Plates 12–19) is in an elaborate frame, the pinnacles of which were painted by Lorenzo Monaco. It is presumed that the altarpiece was begun by Lorenzo Monaco and left unfinished at his death in 1424, the main panel then being undertaken by Fra Angelico. The altarpiece was set up in the sacristy of the church of Santa Trinita in Florence, which was patronized by the Strozzi family, and may have been painted sometime during the 1430s, presumably before 1434 when the Strozzi family were banished from Florence. It is not known how much

freedom Fra Angelico was given in determining the subject-matter and format of the altarpiece, but at all events the composition is particularly daring for a work dating from the first half of the fifteenth century. Indeed, it is not dissimilar from Rogier van der Weyden's *Deposition*, now in Madrid, the composition of which could have been known to Fra Angelico through an engraving. The Florentine altarpiece has a pronounced vertical axis in the centre, marked by the cross, the ladders, and the figures lowering the dead body of Christ. This central part of the altarpiece is related to the side fields geometrically by a triangle. The left side of the triangle extends down the trunk of Christ's body to the kneeling figure of Mary Magdalene, who is seen in profile kissing the feet of Christ. The right side of the triangle is indicated by Christ's left arm, which joins the young St John to the kneeling figure in the foreground seen in three-quarters profile, now identified as a member of the Strozzi family, Beato Alessio degli Strozzi. The pose, gesture, and secular status of this figure imply that he acts as an intermediary on behalf of the spectator. Ranged on either side of the cross, and presided over by hovering angels, are the mourning female figures on the left and the attendant male figures, possibly including Nicodemus and Joseph of Arimathaea, on the right. The range of characterization in the portrayal of these individuals, reacting in their different ways to the horror of Christ's death, is remarkably vivid, and the effect is enhanced by the sharp light entering the picture from the left. Behind these groups of figures are memorable passages of landscape painting. Beyond the male figures is a view of the undulating Tuscan countryside dotted with outlying habitations and trees, or, as John Ruskin wrote of Tuscany in a letter of 1845, 'one vista of vine and blue Apennine, convents and cypresses'. Beyond the female figures is a city representing Jerusalem with the Temple of Solomon rising above all the other buildings. The gateways and the wall, with its series of watch-towers protecting the areas of cultivated land just beyond the perimeter of the city, are exquisitely rendered with the precision of a miniaturist, and sharply defined by the interaction of light and shadow. These two sections of the painting are so well executed, in fact, that they remind one of the shallow relief found on the bronze panels of Ghiberti's Gates of Paradise for the Baptistery in Florence.

Perhaps the most influential of the altarpieces painted by Fra Angelico is that, now rather damaged, executed about 1440 for the church of the convent of San Marco in Florence (Plates 24–27). The composition has a high viewing-point, so that the spectator looks down on the elegant carpet that leads up to the steps of the throne. On this carpet are positioned two pivotal figures: St Cosmas to the left and St Damian to the right. The former implores us in a somewhat theatrical way, with a pathetic gesture and a plaintive expression, to look towards the Virgin, whilst the latter, with his back to the spectator, underlines the invitation, since it seems as though he is a member of the congregation in the main body of the church. These two figures are connected with the Virgin and Child by a simple piece of geometry, in that they form a triangle with them, just as the attendant saints and angels stretched out on either side of the Virgin and Child form the sides of another, larger triangle. The system of perspective also helps to stabilize the composition. The orthogonals on the oriental carpet all lead towards the Virgin and Child, and the distribution of the figures around them creates a feeling of a *sacra conversazione* which the spectator is witnessing – an impression that is reinforced by the looped curtains at the sides, drawn back as though especially for us to see this *tableau vivant*. The high viewing-point means that the figures do not overcrowd the panel as in *The Coronation of the Virgin* (Plate 39),

and it is important to realize how Fra Angelico has united the upper and lower halves of the composition. There is in the centre a strong vertical axis. The Virgin sits on a tall marble throne with a rounded arch and fluted pilasters topped by corinthian capitals and supporting a wide cornice with an entablature. It is a throne very much in the idiom of Brunelleschi, but its real importance for this composition is that it projects almost to the upper edge of the panel. Similarly, the Virgin's head is above the level of the heads of all the other figures. The altarpiece is also divided horizontally into three sections by the carpet below, the backcloth in the middle in front of which the saints stand, and the landscape background above with its rows of cypress and orange trees. The floral swags at the top echo those decorating the cornice of the throne and their curvature recalls that of the looped curtains which reach down to the backcloth, so that the eye, should it follow these lines of suggested pattern, prescribes the outer limits of the upper half of the altarpiece. There is also another geometrical relationship operating on the surface of the panel. The kneeling saints form diagonals that extend into the four corners of the altarpiece and at the same time pass through the figure of the Virgin, thereby drawing attention to the Christ Child. This type of *sacra conversazione* – which Fra Angelico used in two other compositions, though with less dramatic impact (Plates 32 and 33) – was of immense importance for the development of Renaissance painting during the second half of the fifteenth century.

The last of these altarpieces with a unified composition is the large-scale *Coronation of the Virgin* (Plates 39–41), which has been variously dated in the 1430s or as late as about 1450, and was originally painted for the church of the convent of San Domenico in Fiesole. This altarpiece shows how skilfully Fra Angelico could manipulate a vast chorus of figures, for the coronation takes place amid a throng of people. The throne is of large dimensions. It is canopied, decorated by spiral columns on either side with corinthian capitals, and lined with patterned drapery and comfortable cushions. The figures virtually amount to a full cast of Fra Angelico's characters: angels neatly dressed, intent upon their duties or else concentrating upon playing their musical instruments with puffed-out cheeks and deft fingers, and awe-inspired saints, armed with their respective attributes. Those seen in the foreground, kneeling on the patterned floor, are swathed in drapery. In some cases, particularly that of St Agnes on the right holding the lamb, the drapery falls in elegant tubular folds to the ground, whereas the cope of St Nicholas of Bari, seen just to the left of centre in the foreground, is taut, as though pulled together too forcibly at the front. It is a highly worked cope with scenes from Christ's Passion in the embroidered panels at the back, and blends in well with the crowns, diadems and jewels worn by the other saints.

In designing this *Coronation of the Virgin* Fra Angelico set himself a difficult problem in relating the patterned floor to the steep flight of marbled steps. He overcame this, however, by using a single, extremely high vanishing-point for the whole altarpiece, which serves to focus our attention on the coronation at the top. Furthermore, he reinforces this with other indications, such as the jar held in Mary Magdalene's left hand. This jar forms the centre of a circle on the perimeter of which, near the upper edge, are the Virgin and Christ. This circle echoes a larger one comprising the figures positioned around the throne, the centre of which falls in the middle of the flight of steps. Writers have all too easily found fault with Fra Angelico's design of this altarpiece, but the overall impact is, in fact, extremely dramatic. The void left in the centre of the panel, for instance, is not only supremely evocative, but is also composi-

tionally of the greatest possible significance. It is the void around which all the figures gyrate, but at the same time it is the area through which the vertical axis passes, so that the eye has no difficulty in ascending the steep flight of steps until it reaches the focal point of the altarpiece. This vertical line is punctuated only by the jar held by Mary Magdalene and by the quill which the saint on her left is holding. Both these figures are positioned immediately below the Virgin and Christ, and again this vertical emphasis helps to weld together the upper and lower halves of the panel. Such a moment of quietude as this void represents amidst the resplendent throng reveals Fra Angelico at the height of his powers, and the altarpiece cannot justifiably be described as 'one of the few works in which Fra Angelico was thrown off his stride by strenuous efforts to keep up with the innovations visible around him'. Comparison with the earlier and much smaller panel of the *Virgin and Child enthroned with twelve Angels* (Plate 5) shows that the painter was already aware of the dramatic potentialities of this kind of circular composition set within a panel of vertical format. Here, though, in *The Coronation of the Virgin* (Plate 39), as in *The Deposition* (Plate 12), Fra Angelico can be seen controlling a host of figures within a closely defined architectural setting. It is an extension of *The Annunciation* at Cortona (Plate 7), and in designing the composition Fra Angelico creates a degree of flexibility that is also found in the altarpiece painted for the church of the convent of San Marco (Plate 24).

Fra Angelico's compositional powers included his rendering of narrative. In the predellas to his altarpieces, perhaps as a result of his training as a miniaturist, he succeeds in relating an incident vividly, usually with a minimum of figures. For instance, the predella to the San Marco altarpiece, illustrating scenes from the lives of St Cosmas and St Damian, emphasizes the important role accorded these titular saints in the main part of the altarpiece. Two of these scenes (*The Decapitation of St Cosmas and St Damian* and *The Dream of the Deacon Justinian*), the first located in a landscape and the second in an interior, serve to show how compactly the painter treated his narrative subjects. In the former (Plate 26) the two saints with their three brothers are being put to death in front of a neat row of slender cypress trees just outside a city wall. The figures are roughly disposed on a diagonal leading from the lower left corner of the panel to the upper right corner, a line of vision that extends from the act of brutality in the foreground to the stillness of the hillside in the background. There is a telling contrast between the tense body of the kneeling saint about to be beheaded and the lithe body of the executioner, seen from the back, raising his two-handed sword as he strides forward to administer the final blow. Similarly, there is a dramatic contrast between the floral carpet and the decapitated bodies, and also, in a more general sense, between the beauty of the setting beneath 'a vault of deepest sapphire' and the horror of the act. Indeed, the rhythm of the executioner's deadly stroke is echoed by the curve of the road bending round at the foot of the row of hills. *The Dream of the Deacon Justinian* (Plate 27) also achieves dramatic results by the simplest means. There is a crispness in the handling of paint and in the treatment of light that bespeaks some knowledge of contemporary Netherlandish painting, notably in the depiction of the window on the left and the view into the passage through the doorway on the right. The scene depicts a posthumous miracle performed by St Cosmas and St Damian, who during the course of the fifteenth century became the patron saints of the Medici and were assigned medical attributes. In this panel the saints are shown replacing the cancerous leg of the Deacon Justinian with a good leg removed from an Ethiopian man recently deceased, thereby anticipating modern

surgical practice. The Deacon lies peacefully asleep while the saints, one on either side of the bed, perform the transplant operation with a sense of urgency and a degree of concentration demanded by the occasion. Fra Angelico has here taken great care with the still-life objects. There is the stool on the left, which is seen half in shadow and half in light; the Deacon's shoes, which he has left tidily by the bed; and the bed clothes, as well as the accoutrements of nocturnal rest, either suspended from the bed-head, or balanced precariously on top of it. The scene has a slightly theatrical air. The two saints have clearly entered through the door on the right, which has been left open for a sudden departure. The bed is raised upon a dais. The curtains that the Deacon would no doubt have pulled around him before going to sleep are looped over the rail and catch the glimmering light of the approaching dawn. The images in these two predella panels belonging to the San Marco altarpiece are direct and simple. They are painted with a factual precision but are raised to a higher, almost poetic level by the painter's fertile imagination and powers of observation.

The reformer of the Dominican Order and later its Vicar-General, Giovanni Dominici (1357–1419), exhorted painters to return to the traditional values of spirituality and to adopt a clear, economic style devoid of unnecessary emotion and religious anachronisms. The most admirable demonstration of these criteria is provided by the series of frescoes executed by Fra Angelico, with his workshop assistants, on the upper floor of the convent of San Marco (Plates 28–31). These frescoes were painted in the corridors of the convent and in the individual cells of the monks. They were intended to assist the monastic community in fulfilling their religious vows. Interestingly, John Ruskin referred to these particular frescoes as 'visions' when he saw them in 1845. Beginning with *The Annunciation* at the top of the staircase, the frescoes relate the course of Christ's life from his Birth to his Passion, but only one scene, the *Sermon on the Mount*, illustrates the Ministry. Some of the cells are decorated solely with a fresco of Christ on the Cross, either with or without the ancillary figures. The images are memorable because of their touching simplicity. Both the settings and the figures are restrained by a degree of objectivity which suggests that Christ's life is here being described, or merely recorded, rather than enacted. The painter appears to have deliberately limited the number of figures in the frescoes, and the settings are uncomplicated. Elsewhere in the convent, painted at about the same time, are representations of Dominican saints intended to remind the monks of their allegiance to the Order, the most memorable being *St Peter Martyr enjoining Silence*. These frescoes in San Marco include some of the best-known images in Fra Angelico's œuvre, and indeed the unemotional depiction of these scriptural events induces in the beholder a feeling of meditative calm and of spiritual confidence (Plate 30). Few renderings of the Transfiguration are as challenging and as totally convincing as that painted in Cell No. 6 at San Marco (Plate 31).

There is a similar potency about the equally famous series of panels that once decorated the doors of the silver chest in the church of the Santissima Annunziata in Florence (Plates 42–45). These were begun by Fra Angelico about 1451, probably at the behest of Piero de' Medici, but not completed until after the artist's death, in part by Alesso Baldovinetti. The panels depict scenes from the life of Christ, but there are some extra scenes such as *Pentecost*, *The Coronation of the Virgin*, and *The Last Judgement*. Two other scenes are included for theological purposes: *The Vision of Ezekiel* at the beginning and the *Lex Amoris* at the end. *The Vision of Ezekiel* (Plate 42) is a composition in the form of a wheel. Ezekiel is shown in the lower left corner at the moment of

his vision. He is balanced on the right by Gregory the Great, who wrote a commentary on the relevant biblical passage. Around the hub of the wheel are eight standing figures of the Evangelists and the writers of the canonical epistles, and next to the rim are twelve seated figures of prophets. The image is really a scriptural disquisition in the medieval manner and the literary connotations in this first panel of the series are echoed in the inscriptions placed along the upper and lower edges of each of the other panels, which amount to quotations of parallel texts from the Old and New Testaments. Regardless of their learned allusions, these panels from the silver chest are among Fra Angelico's best-loved compositions (Plate 45).

Fra Angelico's finest work, however, is the series of frescoes in a small chapel in the Vatican (Plates 34–38). The Chapel of Pope Nicholas V is approached through the Stanza della Segnatura and the Stanza d'Eliodoro painted by Raphael when he was at the height of his powers. Entering the Chapel after witnessing the intellectual prowess of Raphael is like plunging into a pool of clear water. The Chapel is rectangular and of small dimensions, with a high ceiling. The narrative frescoes are painted on three sides of the room and comprise three lunettes illustrating six scenes from the Life of St Stephen, with five scenes from the Life of St Lawrence below on the main parts of the walls. Flanking the frescoes on the lateral walls and extending into the vault are eight full-length figures of the Doctors of the Church standing under elaborate canopies. In the four fields of the ribbed vault are the Evangelists. There can be little doubt as to why Fra Angelico was asked to paint scenes from the lives of the Deacons Stephen and Lawrence, for these are the Church's two proto-martyrs, whose activities and martyrdoms served to emphasize the primacy of Rome. It is not surprising to discover that the features of Pope St Sixtus II in the frescoes of *The Ordination of St Lawrence* (Plate 38) and *St Lawrence receiving the Treasures of the Church* (Plate 35) are those of Pope Nicholas V himself.

In its judicious selection of Fra Angelico as its official painter, the papacy was richly rewarded. It is here in Rome that one sees the master's compositional powers at their most developed. The narrative is concisely expressed and the chosen scenes from the lives of the two deacons are made, as far as was feasible, to balance one another. The frescoes represent an advance in Fra Angelico's narrative powers in that the scenes are more densely populated than was usual in his earlier compositions. They also have far richer architectural settings, or, in one isolated instance (*The Expulsion and Stoning of St Stephen*), the landscape is treated on a panoramic scale and is less self-contained than was customary (Plate 37). Where the frescoes are paired, the architectural elements help to unify the compositions. The architecture is thus not used merely as a background, but is given a positive role in the interpretation of the scenes. The only pairing in which this system is not successfully applied is that of *St Lawrence receiving the Treasures of the Church* and *St Lawrence distributing Alms* (Plate 35).

It is possible that Fra Angelico's more persistent use of architecture in these frescoes is related to his freshly awakened interest in building, which resulted from what he saw being constructed in Rome whilst he was working in the Vatican. The frescoes of *St Lawrence distributing Alms* (Plate 35) and *The Ordination of St Lawrence* (Plate 38) do certainly reflect contemporary architectural designs, and the background of the latter was probably inspired by the erection of the tribune in Old St Peter's, which was then being discussed with Leon Battista Alberti and was shortly to be begun after a design by Bernardo Rossellino, though it was never finished.

The influence of Fra Angelico's frescoes in the Vatican on his successors who

worked there has never been sufficiently stressed and there are, it seems, points of contact between the Chapel of Pope Nicholas V and the frescoes by Raphael in the Stanza della Segnatura. The substitution of the features of Pope Nicholas V for those of Pope St Sixtus II in *The Ordination of St Lawrence* (Plate 38), and elements of the composition itself, are also found in Raphael's fresco of *Pope Gregory IX approving the Decretals of the Church*, where Pope Gregory IX is accorded the features of Pope Julius II. Similarly, it is surely not too fanciful to find in Fra Angelico's masterly treatment of the recession of the columns in the background of *St Lawrence distributing Alms* (Plate 35) the germ of an idea that resulted in the background of the more spacious hall in which Raphael set his fresco of *The School of Athens*. If these visual connections are valid, then they may be taken as a supreme compliment to Fra Angelico by his illustrious successor in the Vatican.

Any consideration of Fra Angelico's last works must include *The Adoration of the Magi*, once in the collection of the Medici, but a work of undetermined date (Plates 46 and 47). It is manifestly a panel by two artists, one of whom can be identified as Filippo Lippi, whilst the other may have been Fra Angelico himself or else a former assistant. The figures of the Virgin and Child, the city wall on the right with the figures alongside it, the floral carpet and some of the figures under the arch on the left are in the manner of Fra Angelico. The rest of the panel appears to be by Filippo Lippi. The circular composition and the swaying, rhythmical pattern of the procession, reinforcing the shape of the panel, are devices frequently employed by artists in the second half of the fifteenth century, and here they are employed in an exploratory way for almost the first time. The advantages of the circular composition become apparent as the eye unravels the wealth of elaborate detail covering the closely worked surface. The circumstances of the commission and of the joint authorship are not known, but whatever the final answer may be, there is a certain justice in the fact that the styles of the two most distinguished painters working in Florence after the death of Masaccio have been perfectly blended in a painting of this quality.

Select Bibliography

Vasari, G., *Lives of the Most Eminent Painters, Sculptors, and Architects* (translated by G. Bull). Penguin Books, London, 1960. (The passage from Vasari quoted in the text is taken from the first complete English edition, translated by Mrs Jonathan Foster, published in five volumes as part of Bohn's Standard Library between 1855 and 1864.)

Pope-Hennessy, J., *Fra Angelico*, 2nd edn. London, 1974.

Baldini, U., *L'opera completa dell'Angelico*. Milan, 1970.

Orlandi, S. (O.P.), *Beato Angelico*. Florence, 1964.

Outline Biography

List of Plates

21. *The Virgin and Child enthroned with four Angels.* 1438. Centre panel of an altarpiece. Panel, 137 × 68 cm. Cortona, Museo Diocesano.

22. *St Dominic and St Nicholas of Bari.* 1437. Side panel from the Perugia altarpiece (Plate 20). Panel, 95 × 73 cm. Perugia, Galleria Nazionale dell'Umbria.

23. *St John the Baptist and St Catherine of Alexandria.* 1437. Side panel from the Perugia altarpiece (Plate 20). Panel, 95 × 73 cm. Perugia, Galleria Nazionale dell' Umbria.

24. *The San Marco Altarpiece: The Virgin and Child enthroned with Angels and SS. Cosmas and Damian, Lawrence, John the Evangelist, Mark, Dominic, Francis, and Peter Martyr.* About 1440. Panel, 220 × 227 cm. Florence, Museo di San Marco.

25. *The Entombment.* About 1440. Panel from the predella of the San Marco altarpiece (Plate 24). Panel, 38 × 46 cm. Munich, Alte Pinakothek.

26. *The Decapitation of St Cosmas and St Damian.* About 1440. Panel from the predella of the San Marco altarpiece (Plate 24). Panel, 36 × 46 cm. Paris, Louvre.

27. *The Dream of the Deacon Justinian.* About 1440. Panel from the predella of the San Marco altarpiece (Plate 24). Panel, 37 × 45 cm. Florence, Museo di San Marco.

28. *The Annunciation.* About 1441–3. Fresco, 187 × 157 cm. Florence, San Marco (Cell 3).

29. *Noli Me Tangere.* About 1441–3. Fresco, 177 × 139 cm. Florence, San Marco (Cell 1).

30. *The Mocking of Christ.* About 1441–3. Fresco, 195 × 159 cm. Florence, San Marco (Cell 7).

31. *The Transfiguration.* About 1441–3. Fresco, 189 × 159 cm. Florence, San Marco (Cell 6).

32. *The Annalena Altarpiece: The Virgin and Child enthroned with SS. Peter Martyr, Cosmas and Damian, John the Evangelist, Lawrence, and Francis.* About 1445. Panel, 180 × 202 cm. Florence, Museo di San Marco.

33. *The Bosco ai Frati Altarpiece: The Virgin and Child enthroned with two Angels between SS. Anthony of Padua, Louis of Toulouse, and Francis, and SS. Cosmas and Damian and Peter Martyr.* About 1450. Panel, 174 × 174 cm. Florence, Museo di San Marco.

34. *St Stephen preaching and St Stephen addressing the Council.* About 1447–8. Fresco, 322 × 412 cm. Vatican, Chapel of Pope Nicholas V.

35. *St Lawrence receiving the Treasures of the Church and St Lawrence distributing Alms.* About 1447–8. Fresco, 271 × 410 cm. Vatican, Chapel of Pope Nicholas V.

36. *St Lawrence before Valerianus* (left half of *St Lawrence before Valerianus and The Martyrdom of St Lawrence*). About 1447–8. Fresco, 271 × 473 cm. Vatican, Chapel of Pope Nicholas V.

37. *The Stoning of St Stephen* (right half of *The Expulsion of St Stephen and The Stoning of St Stephen*). About 1447–8. Fresco, 322 × 236 cm. Vatican, Chapel of Pope Nicholas V.

38. *The Ordination of St Lawrence.* About 1447–8. Fresco, 271 × 197 cm. Vatican, Chapel of Pope Nicholas V.

39. *The Coronation of the Virgin.* About 1450. Panel, 213 × 211 cm. Paris, Louvre.

40. Detail of Plate 39.

41. Detail of Plate 39.

42. *The Vision of Ezekiel.* About 1451. Panel, 39 × 39 cm. Florence, Museo di San Marco.

43. *The Massacre of the Innocents.* About 1451. Panel, 39 × 39 cm. Florence, Museo di San Marco.

44. *The Circumcision.* About 1451. Panel, 39 × 39 cm. Florence, Museo di San Marco.

45. *The Flight into Egypt.* About 1451. Panel, 39 × 39 cm. Florence, Museo di San Marco.

46. *The Adoration of the Magi* (with Filippo Lippi). About 1452–3. Panel, 137.4 cm. (diameter). Washington, National Gallery of Art (Kress Collection).

47. Detail of Plate 46.

48. *Christ on the Cross with the Virgin and St John the Evangelist adored by a Dominican Cardinal.* About 1450–55. Panel, 88 × 36 cm. Cambridge (Massachusetts), Fogg Art Museum.

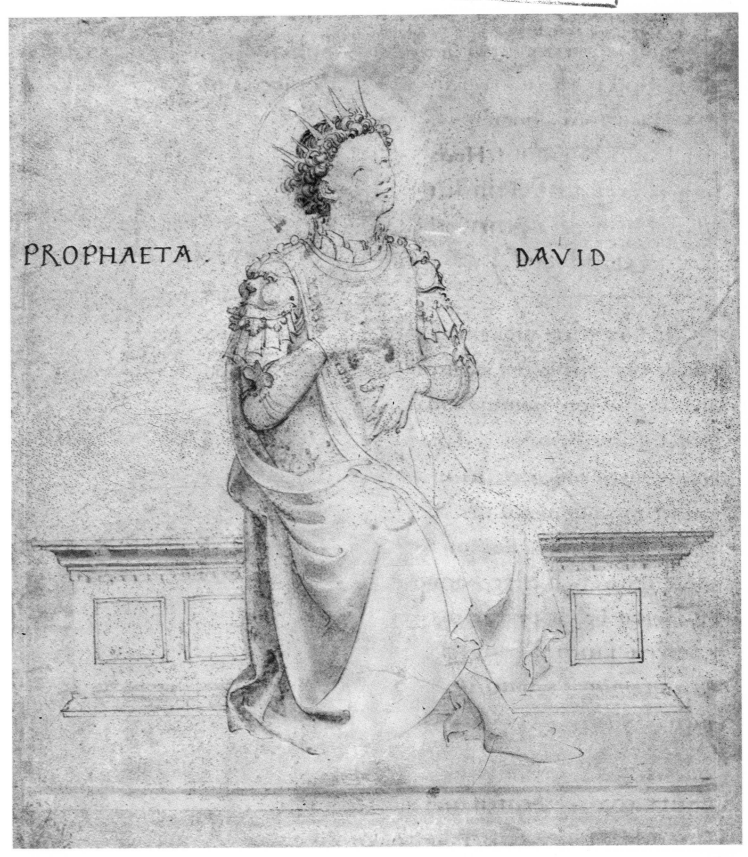

PROPHAETA. DAVID

1. *King David playing a Psaltery.* About 1430.
London, British Museum

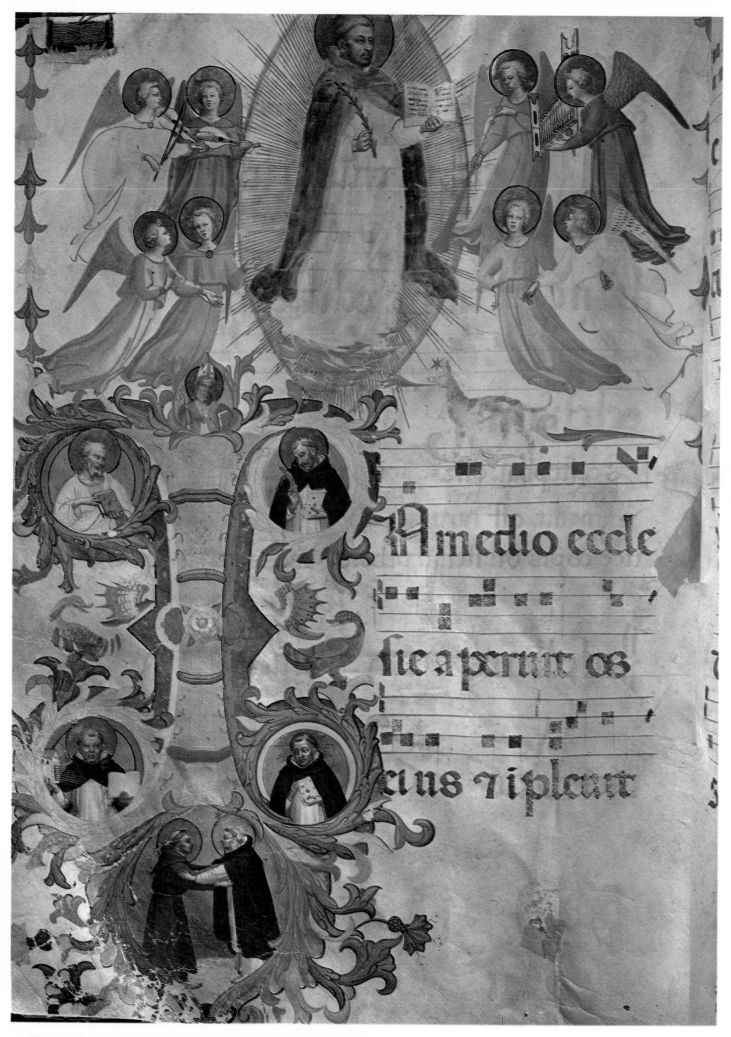

2. *The Glorification of St Dominic*. Detail from a Missal (No. 558 f. 67 verso). About 1430.
Florence, Museo di San Marco

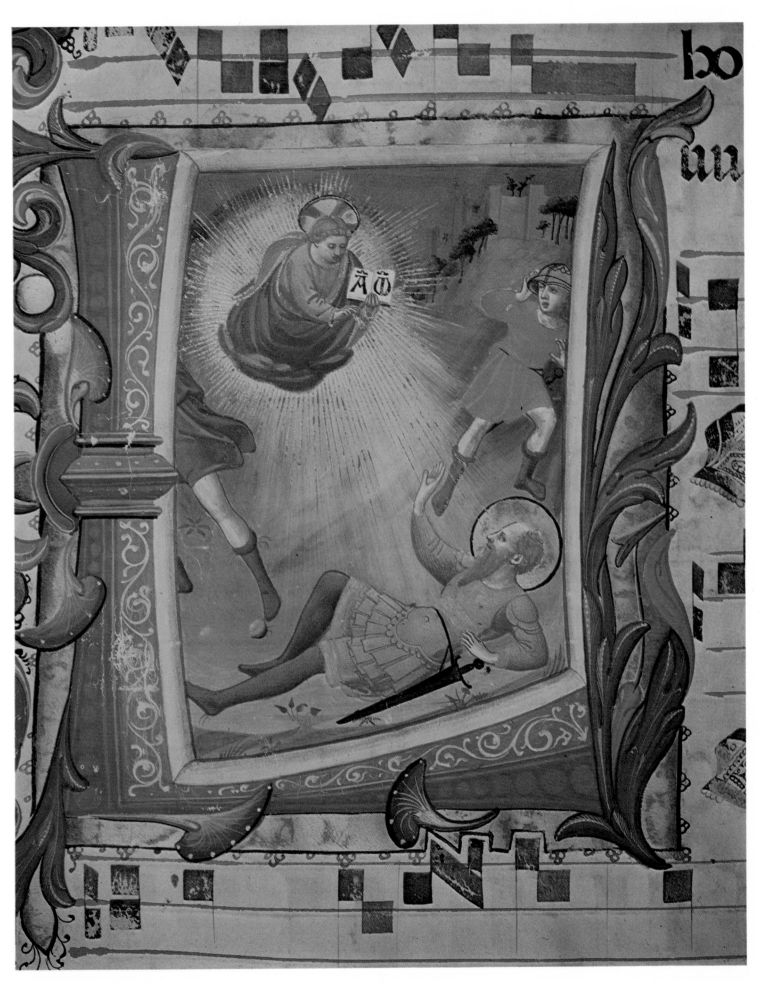

3. *The Conversion of St Paul*. Detail from a Missal (No. 558 f. 21). About 1430.
Florence, Museo di San Marco

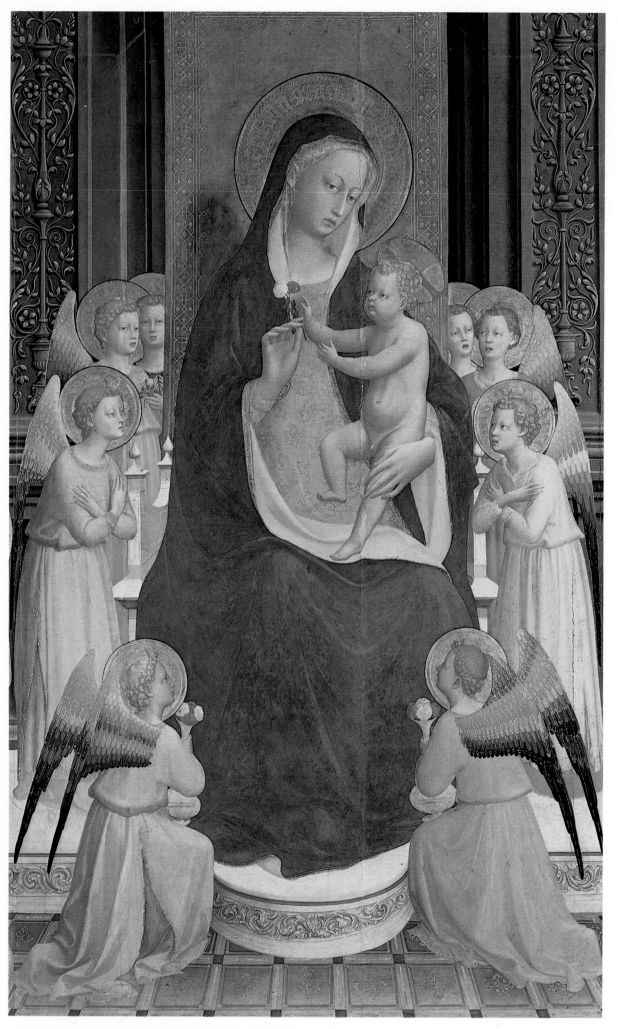

4. *The Virgin and Child enthroned with eight Angels.* Centre panel of an altarpiece. About 1425.
Fiesole, San Domenico

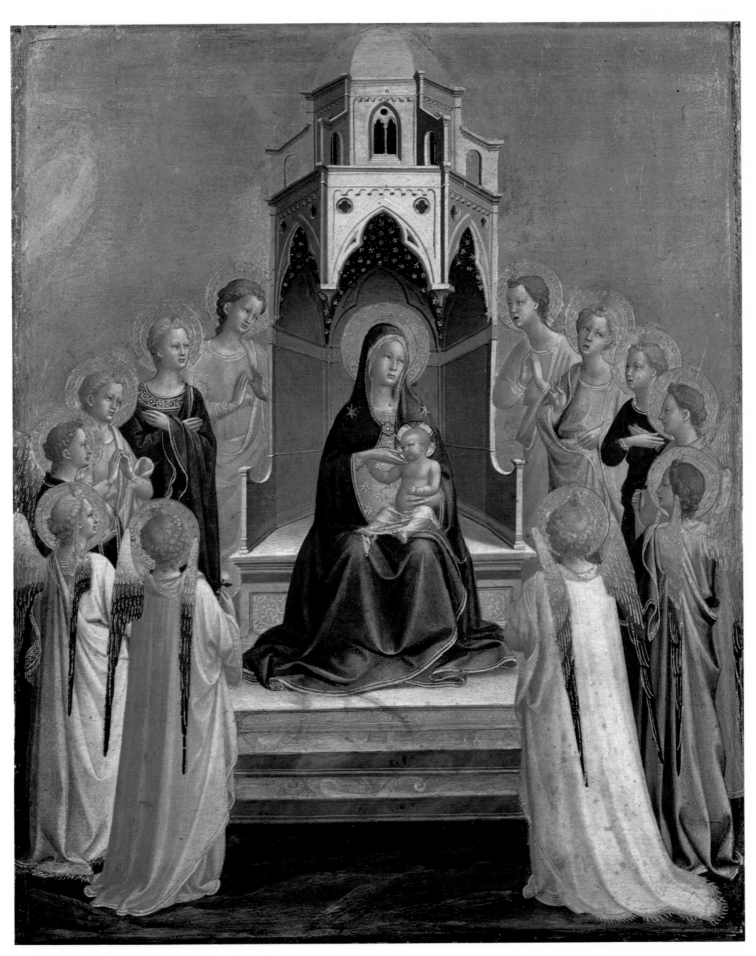

5. *The Virgin and Child enthroned with twelve Angels*. About 1430–33.
Frankfurt-am-Main, Staedelsches Kunstinstitut

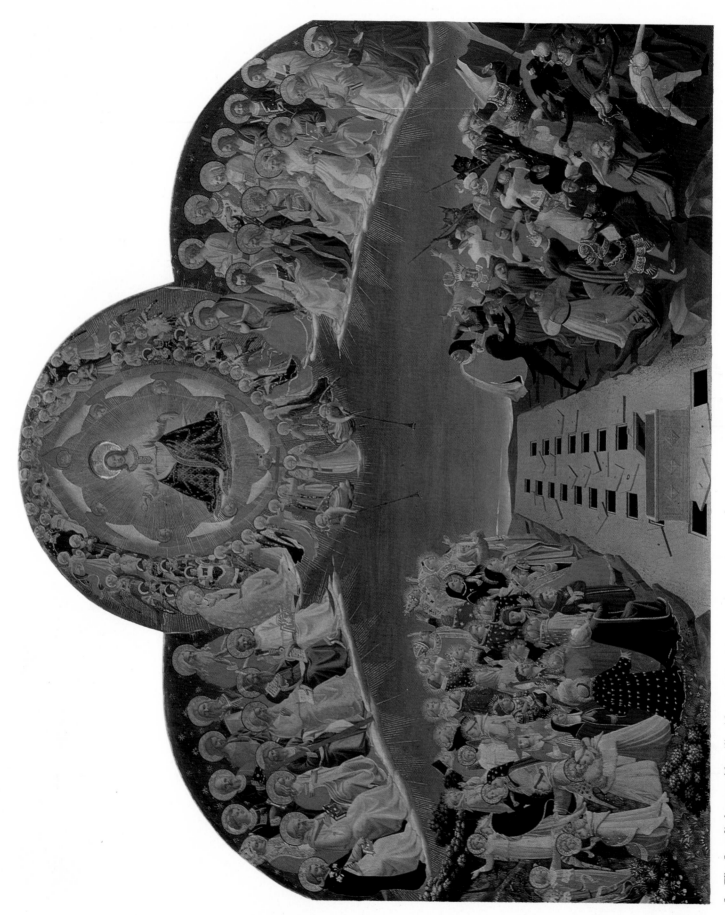

6. *The Last Judgement* (detail). About 1430–33.
Florence, Museo di San Marco

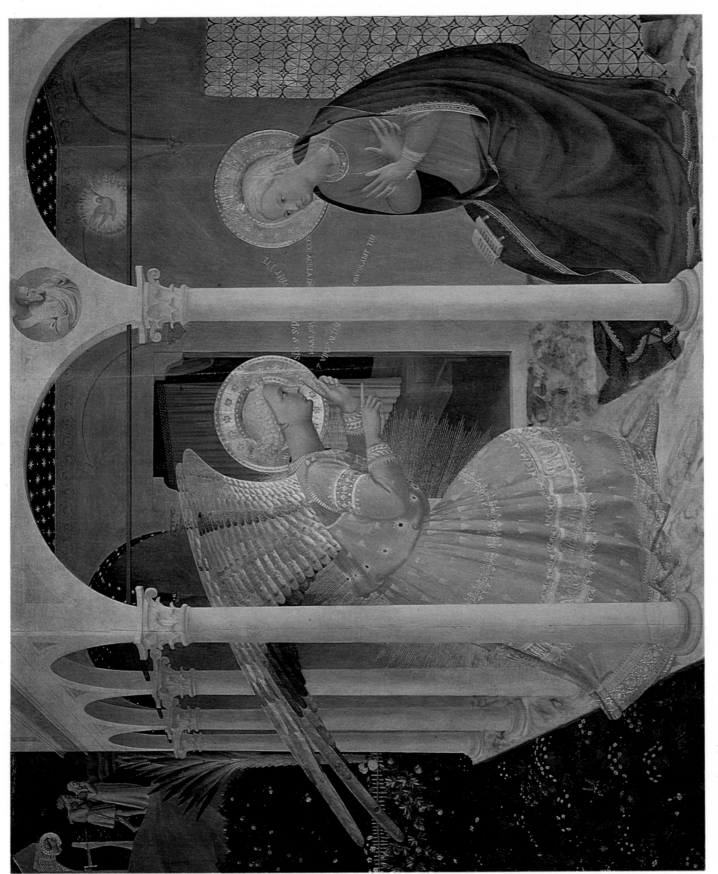

7. *The Annunciation*. About 1432–3.
Cortona, Museo Diocesano

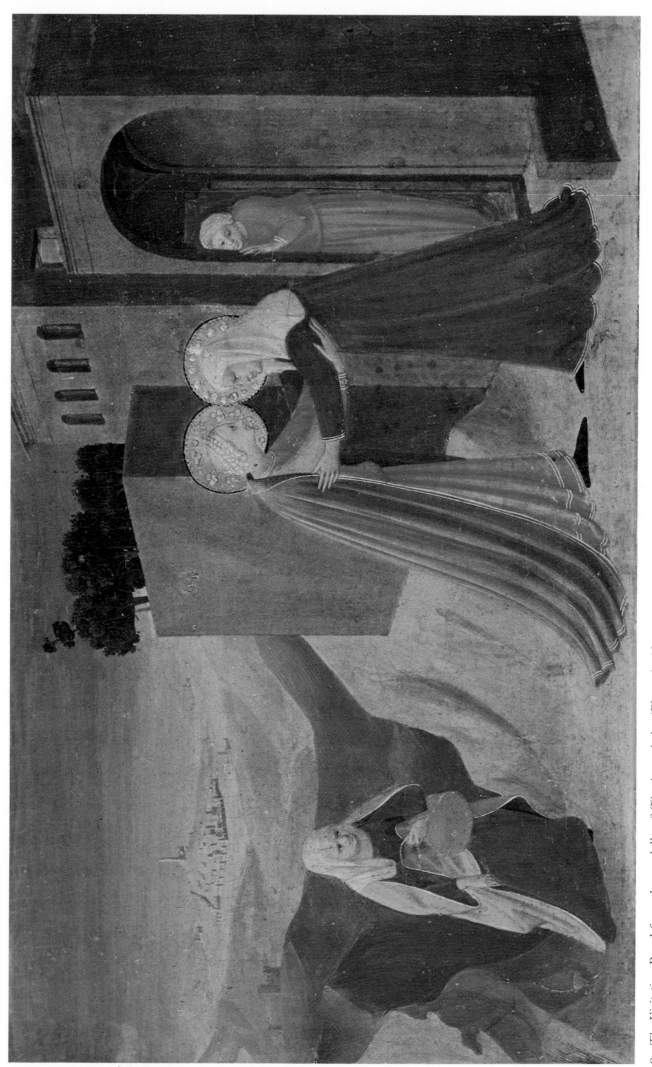

8. *The Visitation*. Panel from the predella of *The Annunciation* (Plate 7). About 1432–3. Cortona, Museo Diocesano

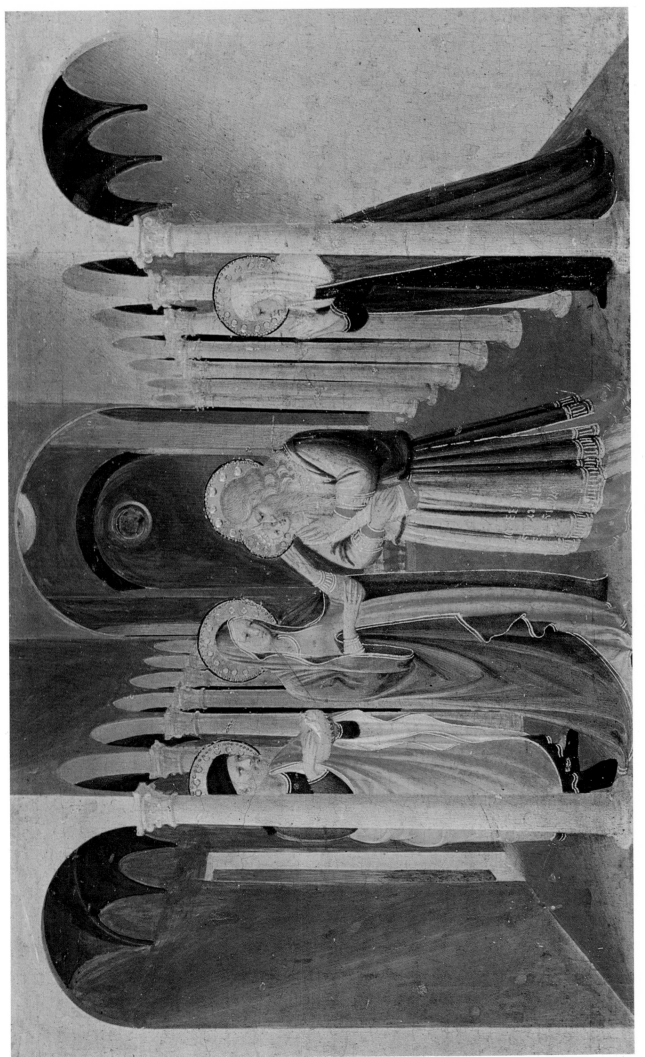

9. *The Presentation of Christ in the Temple*. Panel from the predella of *The Annunciation* (Plate 7). About 1432–3. Cortona, Museo Diocesano

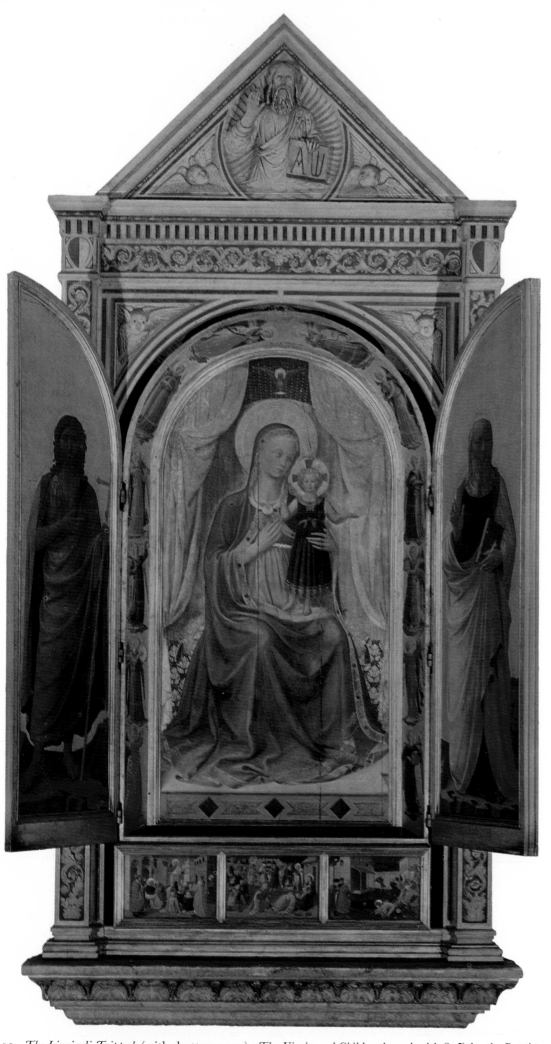

10. *The Linaiuoli Triptych* (with shutters open): *The Virgin and Child enthroned with St John the Baptist and St Mark.* 1433. Florence, Museo di San Marco

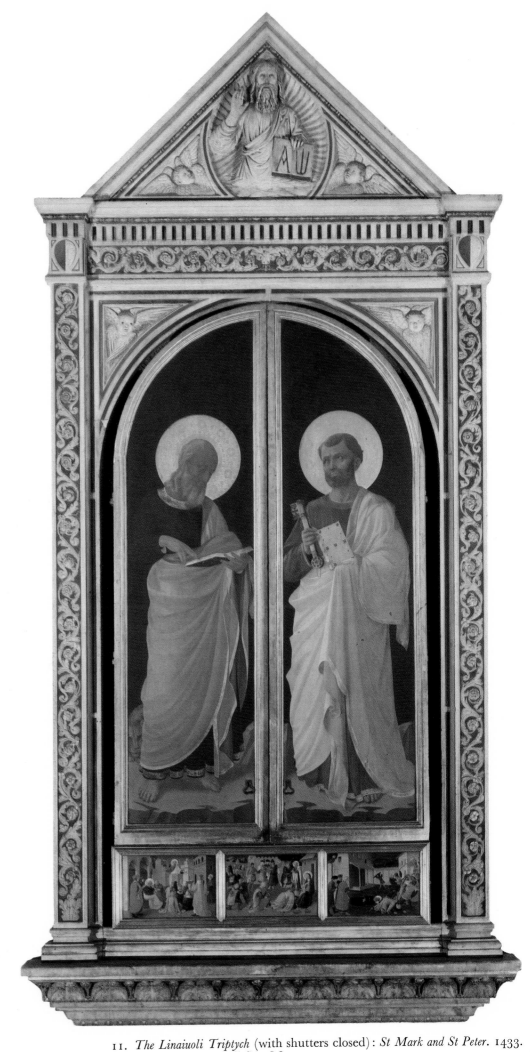

11. *The Linaiuoli Triptych* (with shutters closed): *St Mark and St Peter.* 1433.
Florence, Museo di San Marco

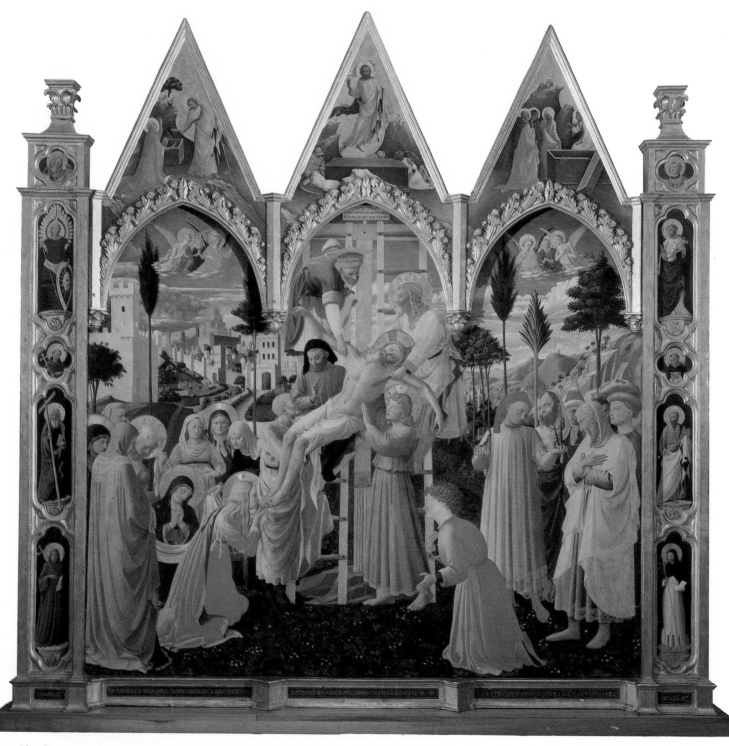

12. *The Deposition from the Cross*. About 1433–4.
Florence, Museo di San Marco

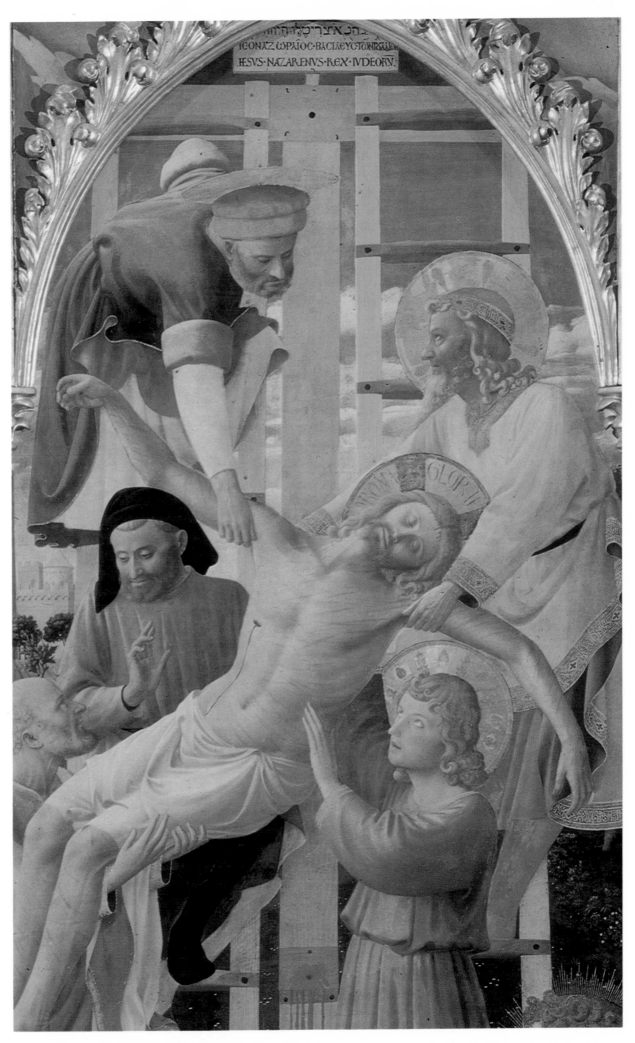

13. Detail of Plate 12

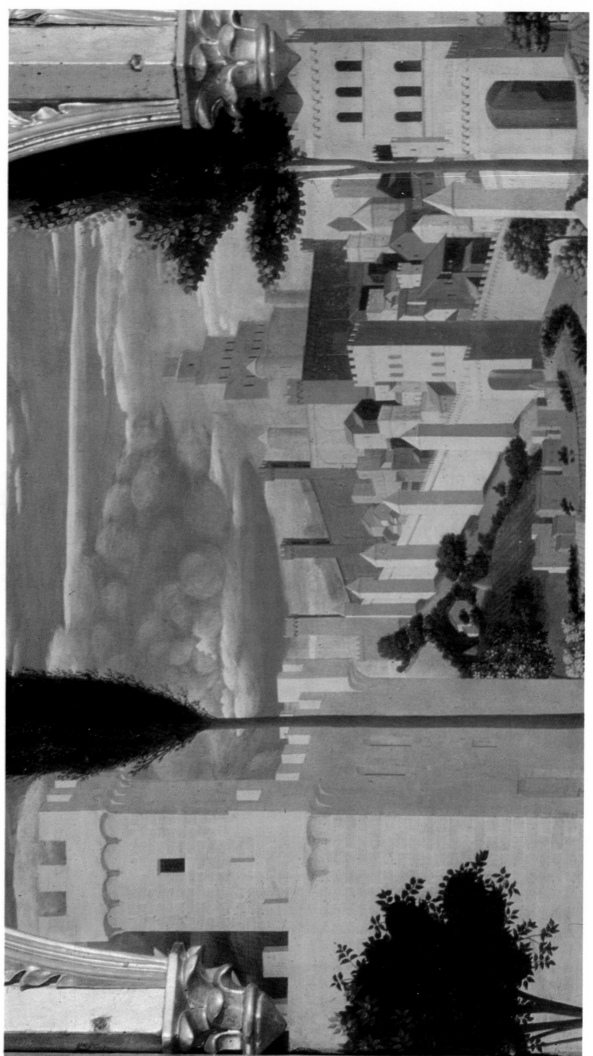

14. Detail of Plate 12

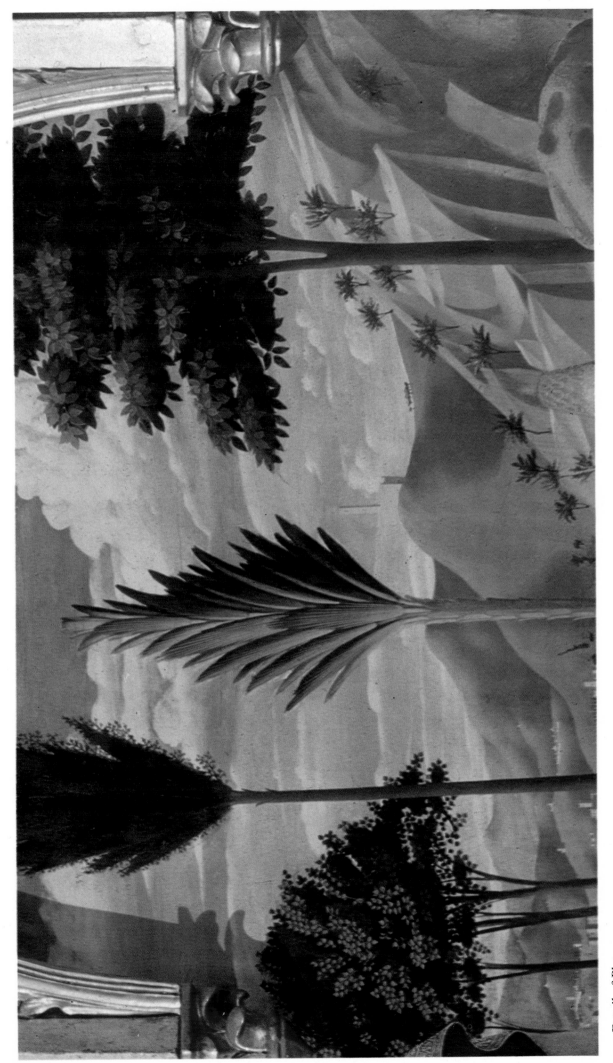

15. Detail of Plate 12

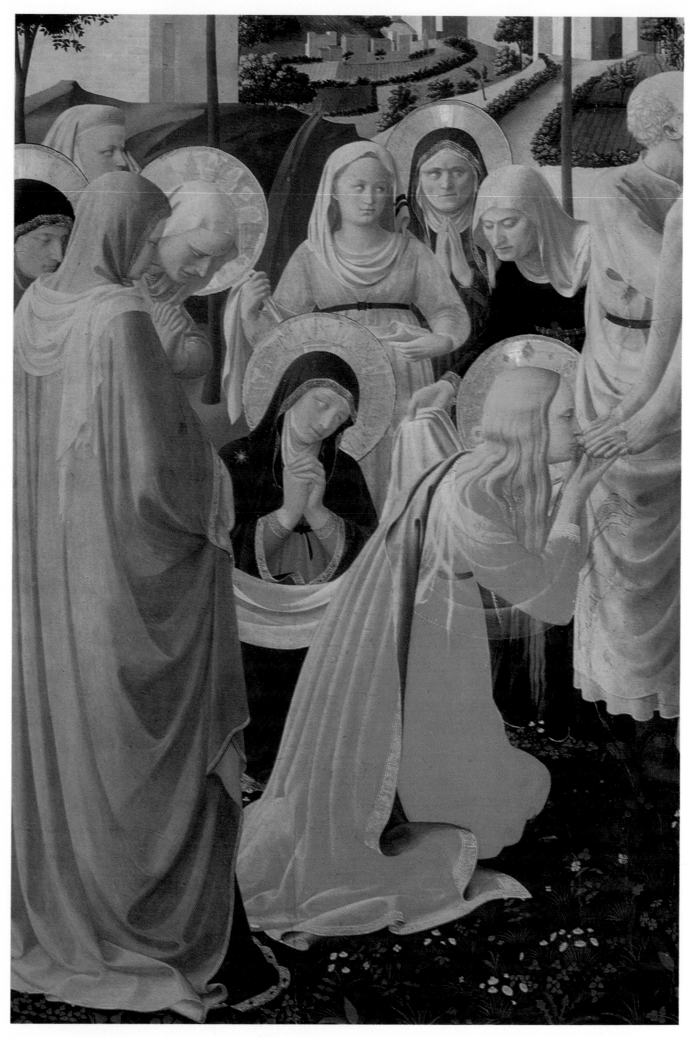

16. Detail of Plate 12

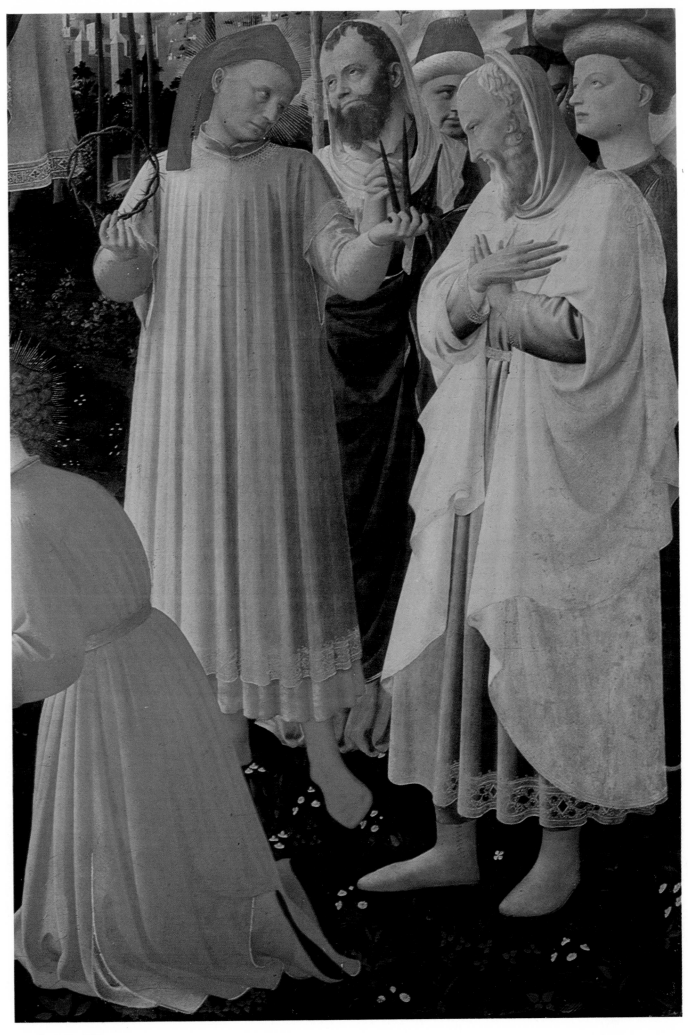

17. Detail of Plate 12

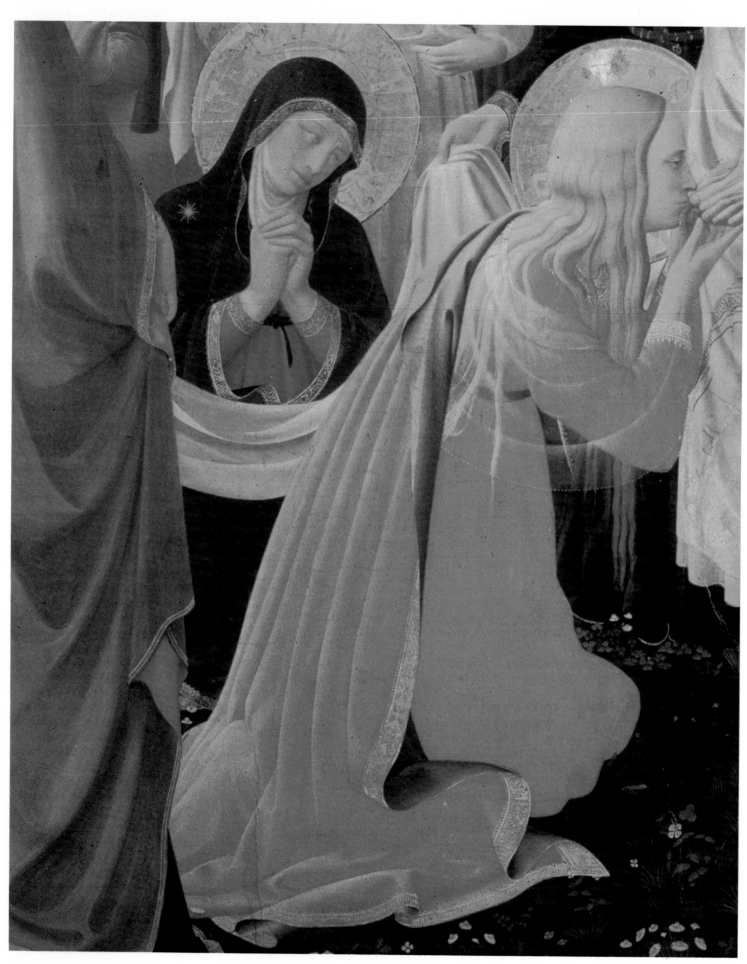

18. Detail of Plate 12

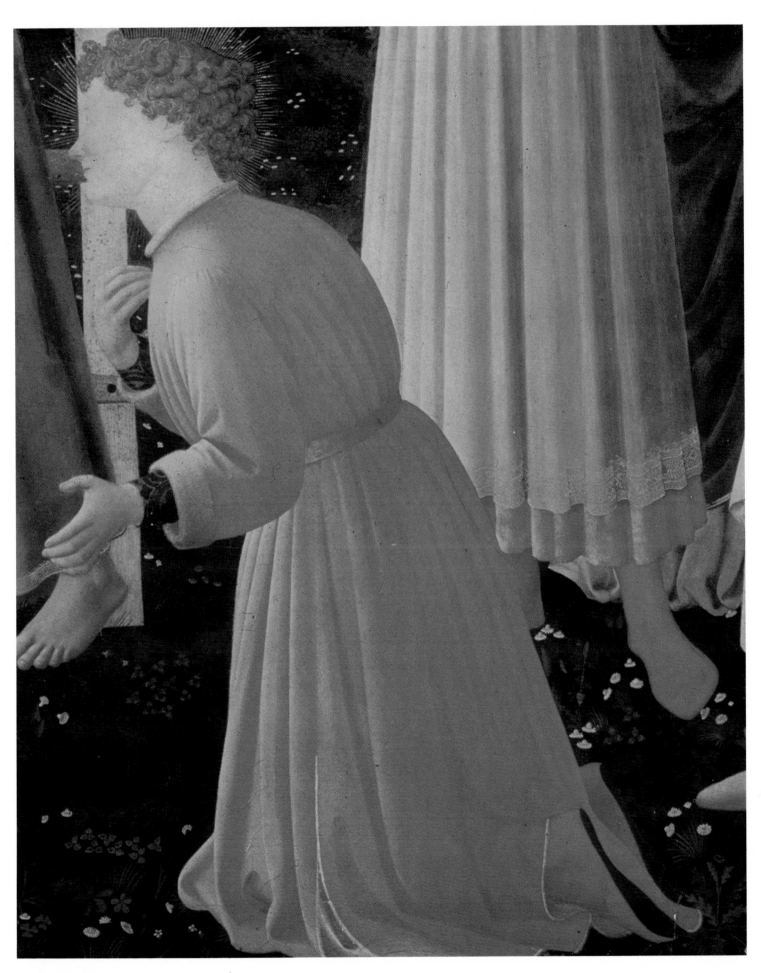

19. Detail of Plate 12

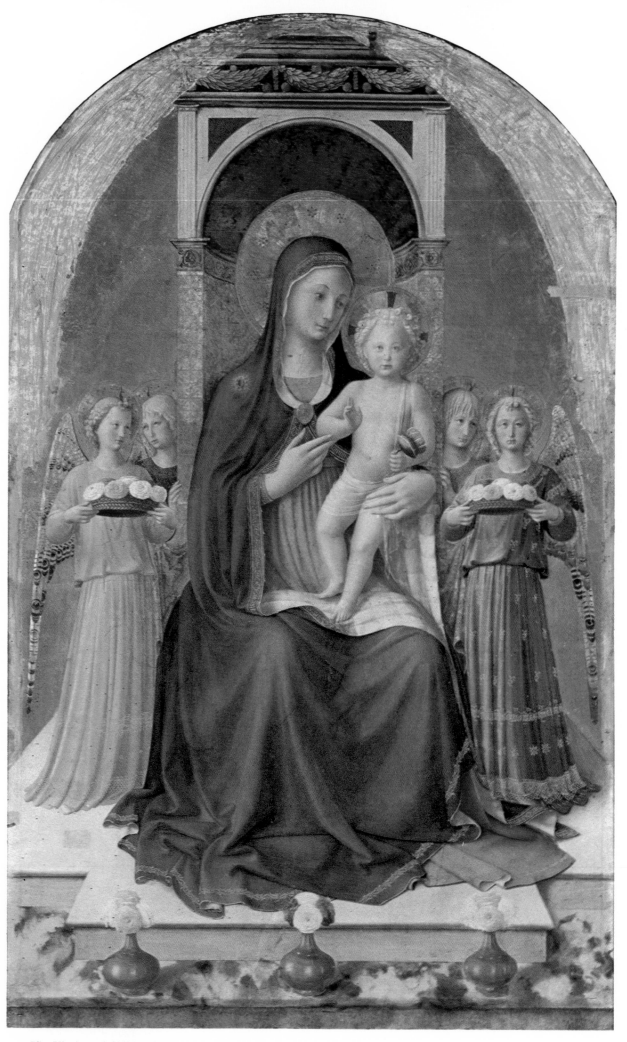

20. *The Virgin and Child enthroned with four Angels.* Centre panel of an altarpiece. 1437.
Perugia, Galleria Nazionale dell'Umbria

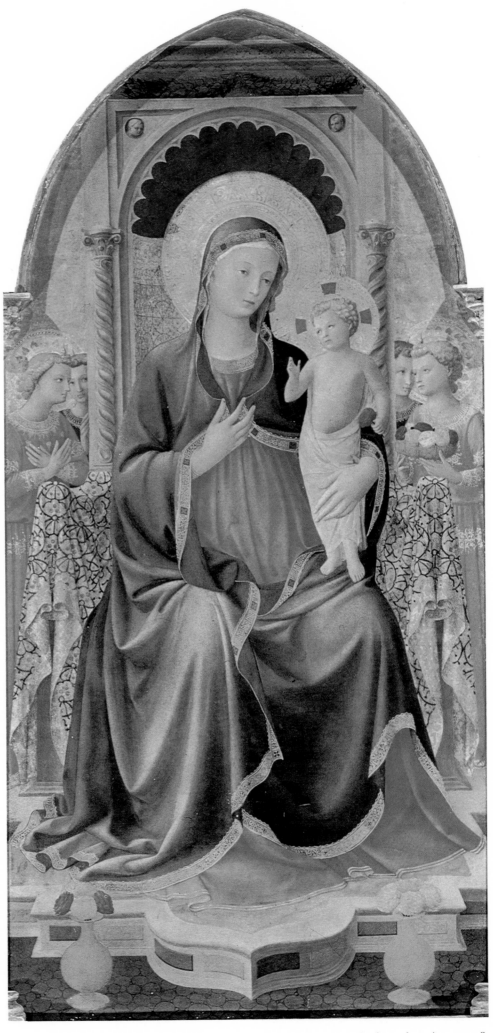

21. *The Virgin and Child enthroned with four Angels*. Centre panel of an altarpiece. 1438. Cortona, Museo Diocesano

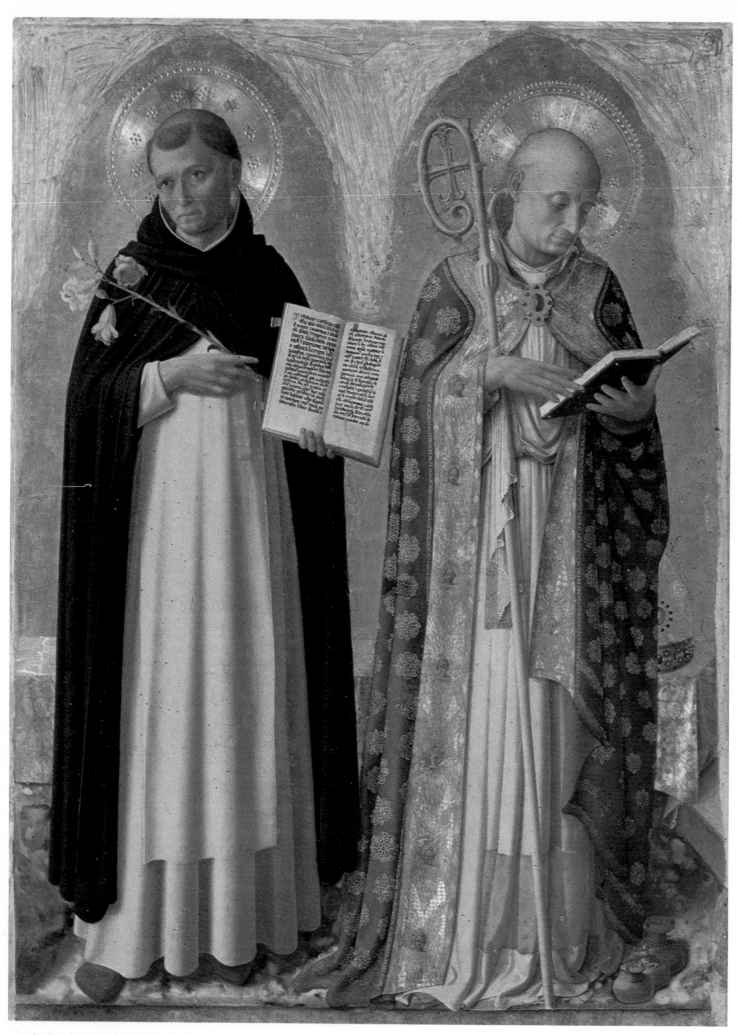

22. *St Dominic and St Nicholas of Bari*. Side panel from the Perugia altarpiece (Plate 20). 1437.
Perugia, Galleria Nazionale dell'Umbria

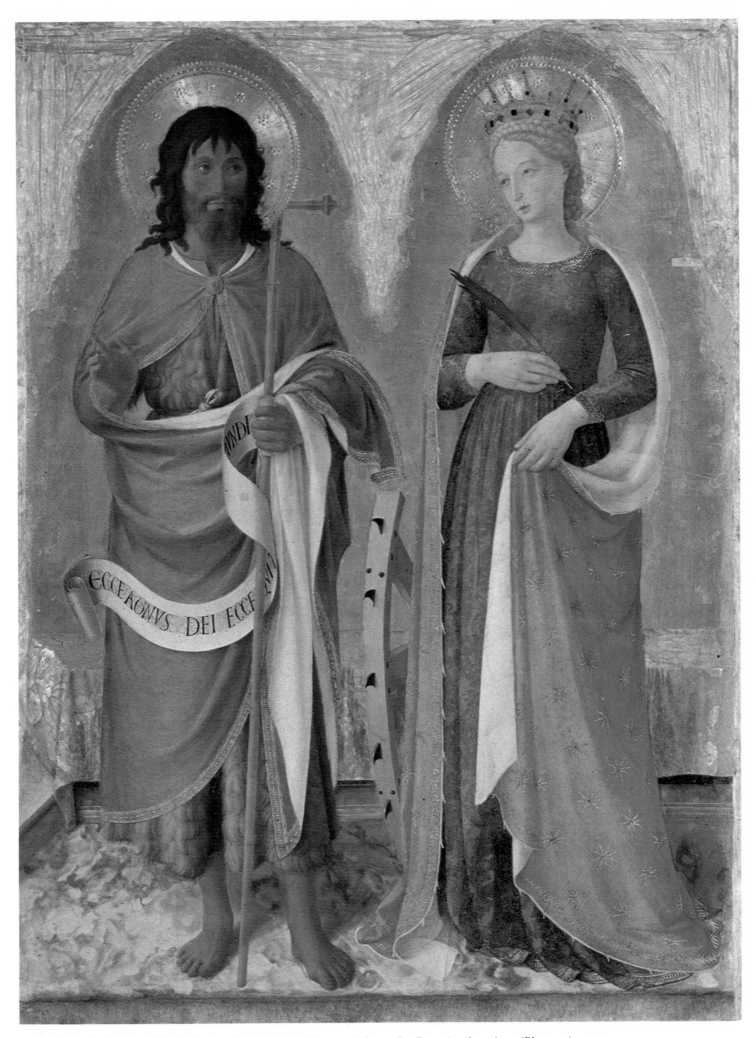

23. *St John the Baptist and St Catherine of Alexandria.* Side panel from the Perugia altarpiece (Plate 20). 1437. Perugia, Galleria Nazionale dell'Umbria

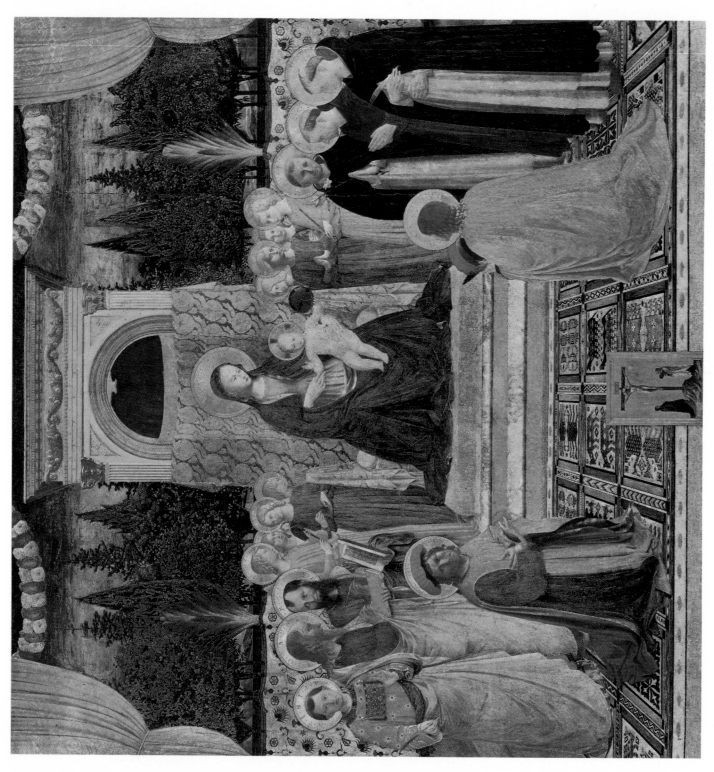

24. *The San Marco Altarpiece: The Virgin and Child enthroned with Angels and SS. Cosmas and Damian, Lawrence, John the Evangelist, Mark, Dominic, Francis, and Peter Martyr.* About 1440. Florence, Museo di San Marco

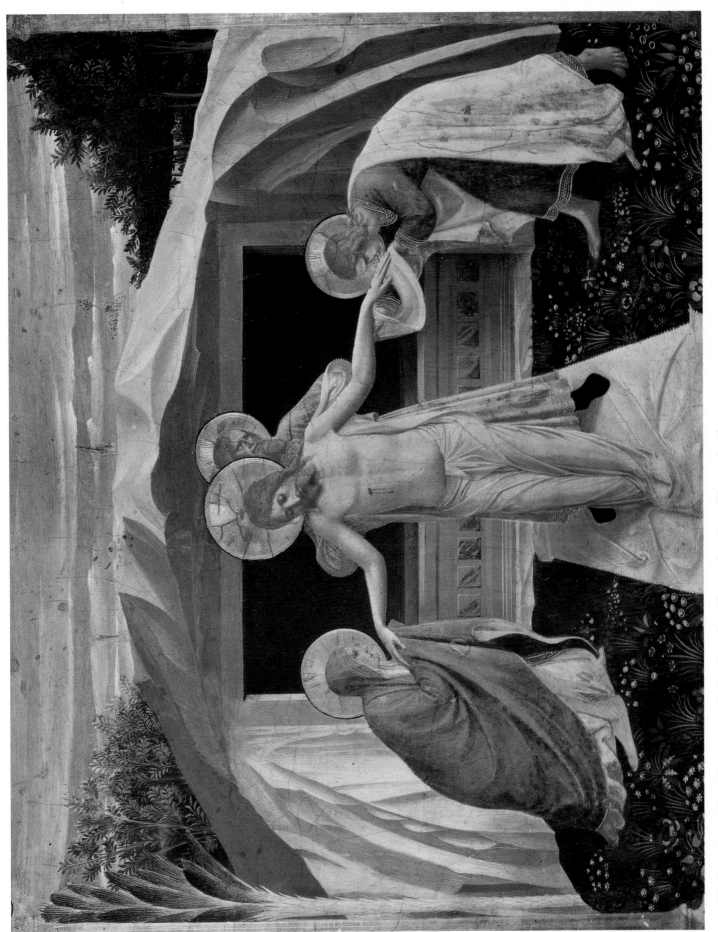

25. *The Entombment.* Panel from the predella of the San Marco altarpiece (Plate 24). About 1440. Munich, Alte Pinakothek

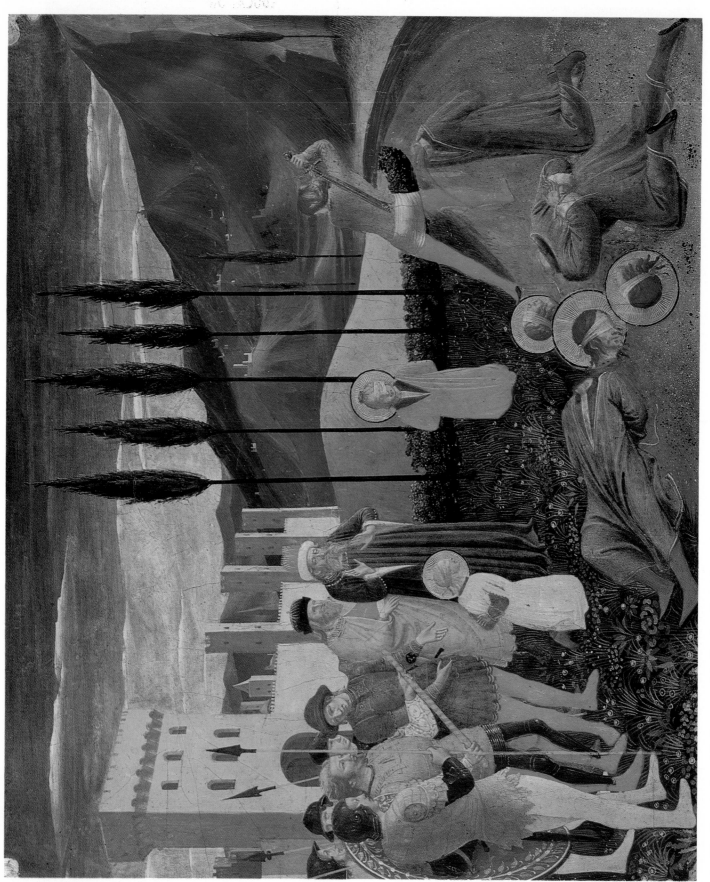

26. *The Decapitation of St Cosmas and St Damian.* Panel from the predella of the San Marco altarpiece (Plate 24). About 1440. Paris, Louvre

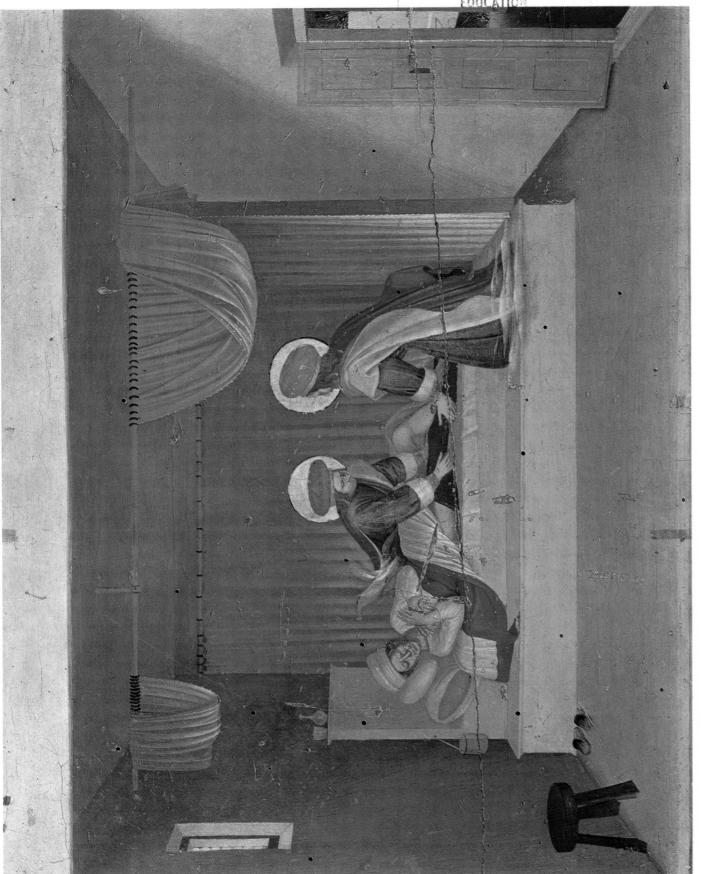

27. *The Dream of the Deacon Justinian.* Panel from the predella of the San Marco altarpiece (Plate 24). About 1440. Florence, Museo di San Marco

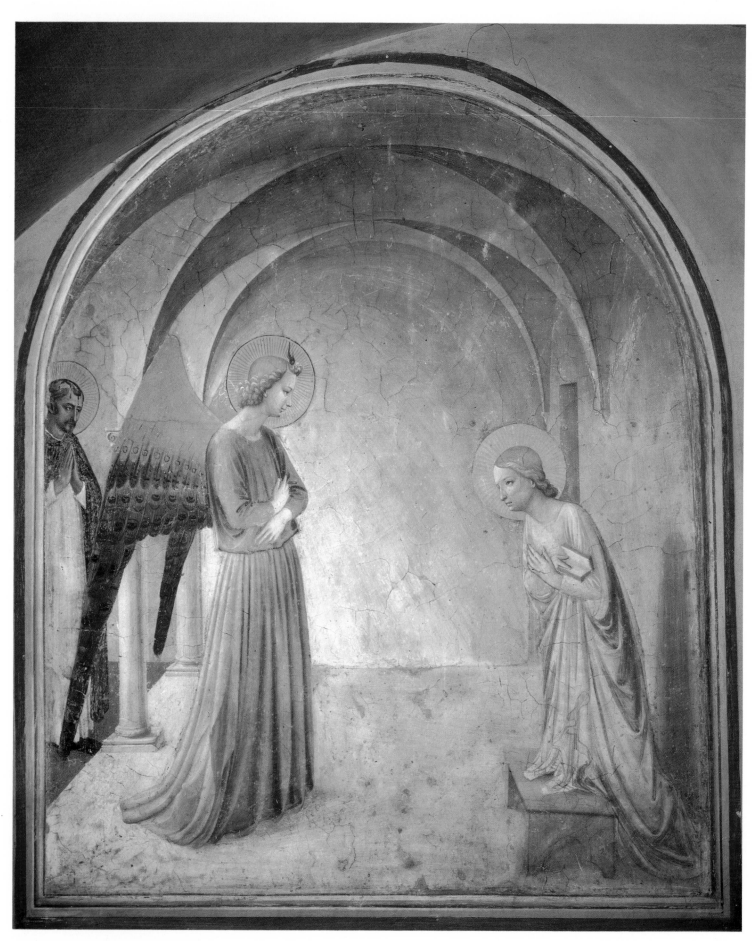

28. *The Annunciation*. About 1441-3.
Florence, San Marco (Cell 3)

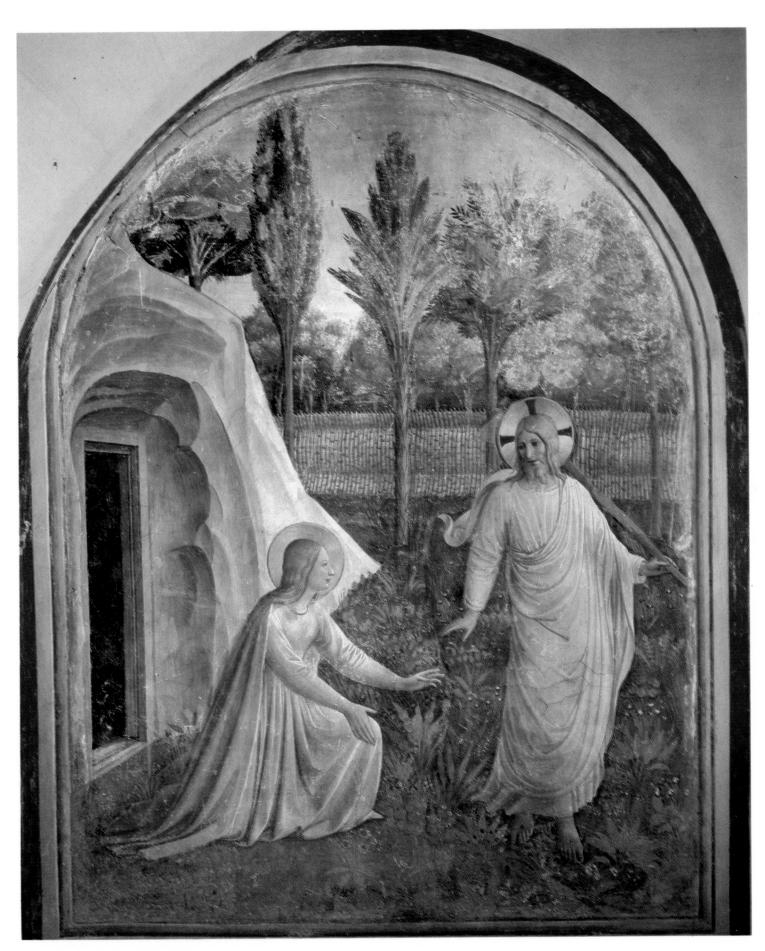

29. *Noli Me Tangere.* About 1441–3.
Florence, San Marco (Cell 1)

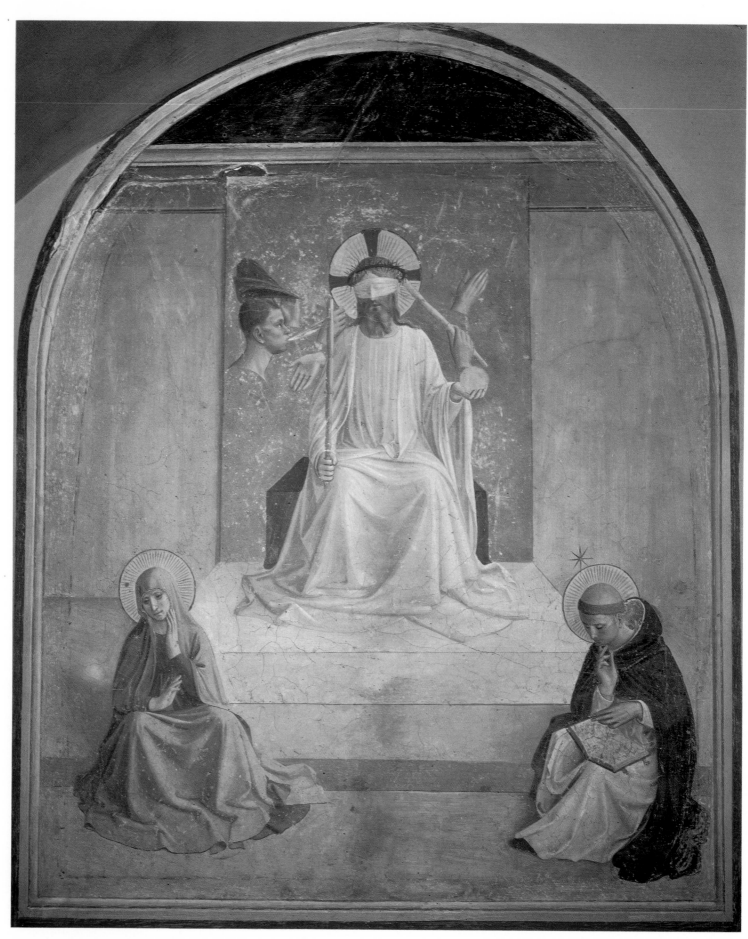

30. *The Mocking of Christ.* About 1441–3.
Florence, San Marco (Cell 7)

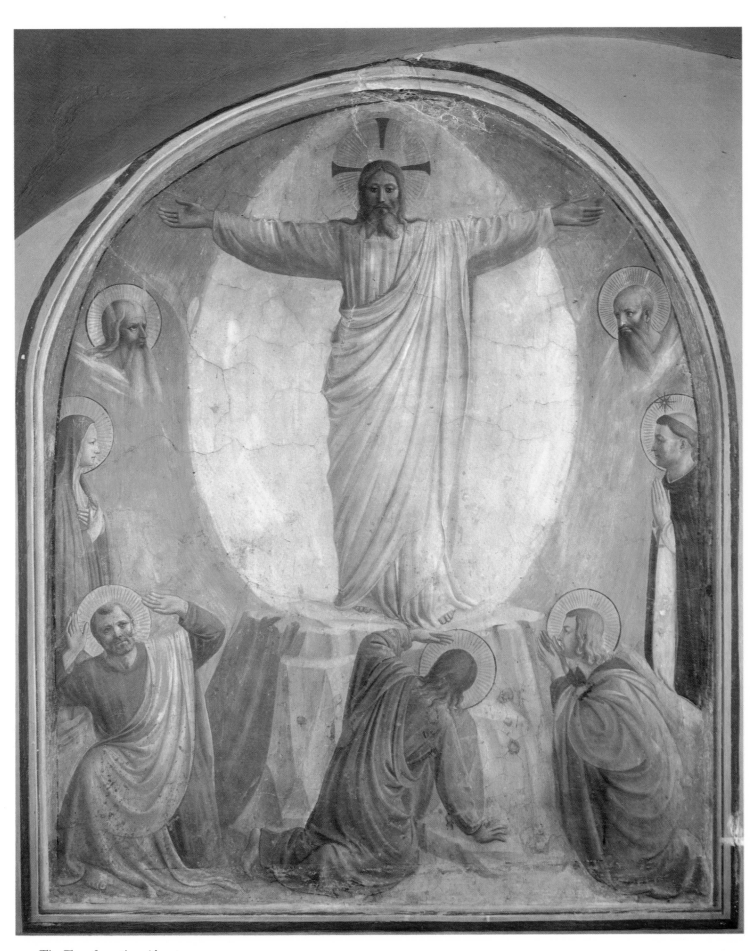

31. *The Transfiguration.* About 1441–3.
Florence, San Marco (Cell 6)

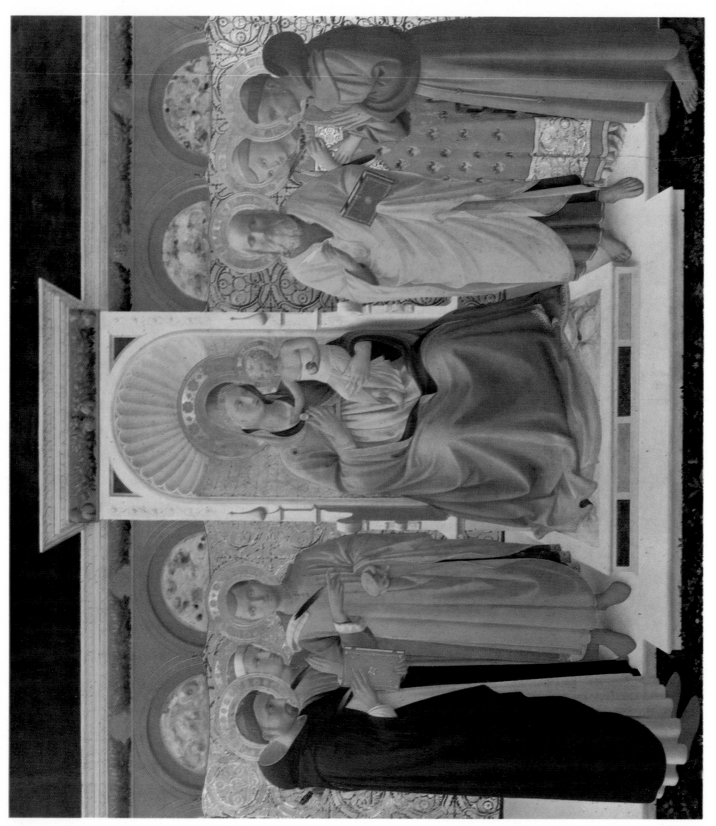

32. *The Annalena Altarpiece : The Virgin and Child enthroned with SS. Peter Martyr, Cosmas and Damian, John the Evangelist, Lawrence, and Francis.* About 1445. Florence, Museo di San Marco

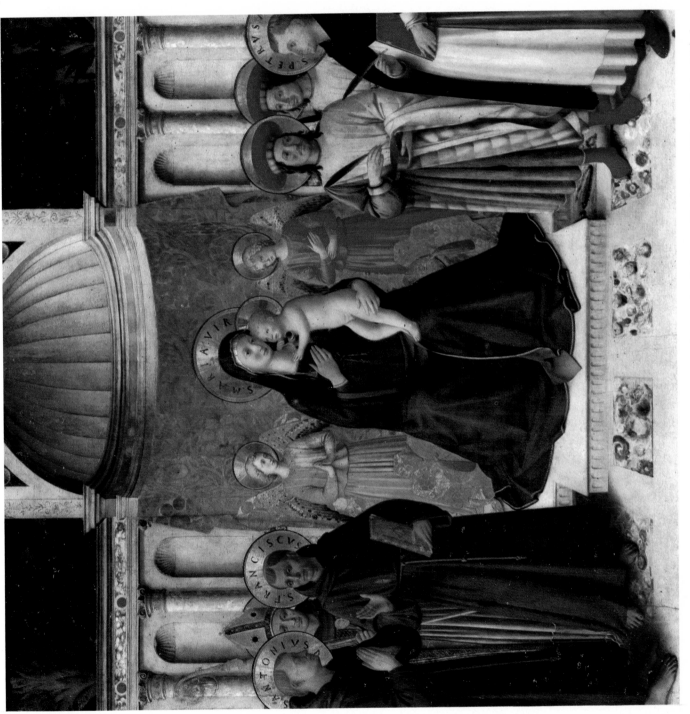

33. *The Bosco ai Frati Altarpiece: The Virgin and Child enthroned with two Angels between SS. Anthony of Padua, Louis of Toulouse, and Francis, and SS. Cosmas and Damian and Peter Martyr.* About 1450. Florence, Museo di San Marco

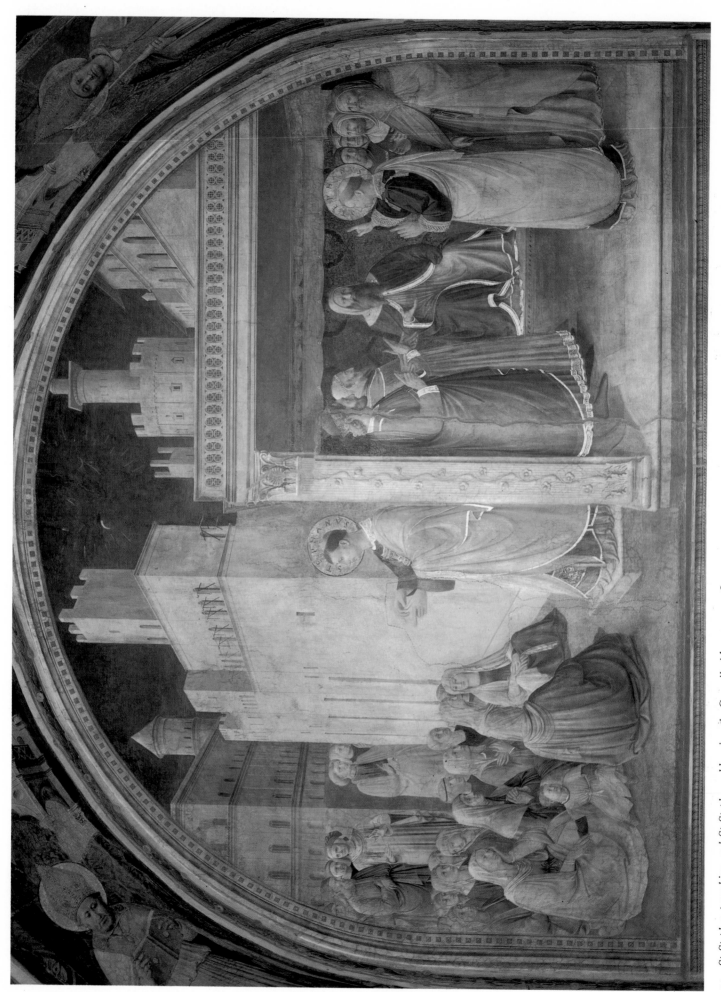

34. *St Stephen preaching and St Stephen addressing the Council. About 1447–8.*
Vatican, Chapel of Pope Nicholas V

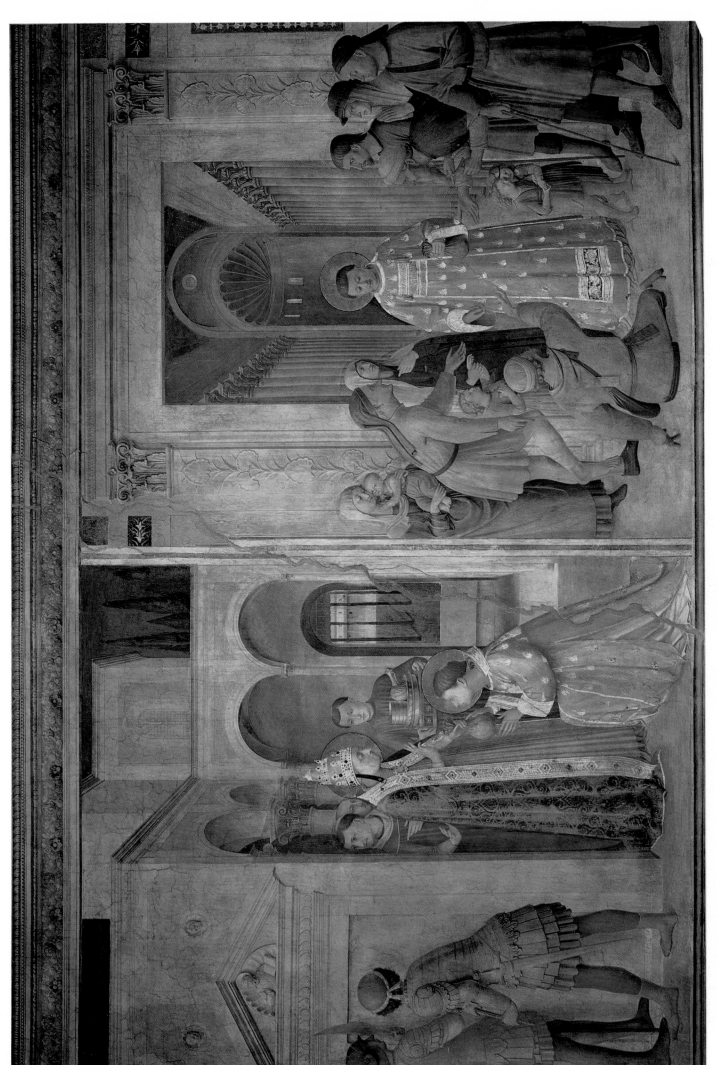

35. *St Lawrence receiving the Treasures of the Church and St Lawrence distributing Alms.* About 1447–8.
Vatican, Chapel of Pope Nicholas V

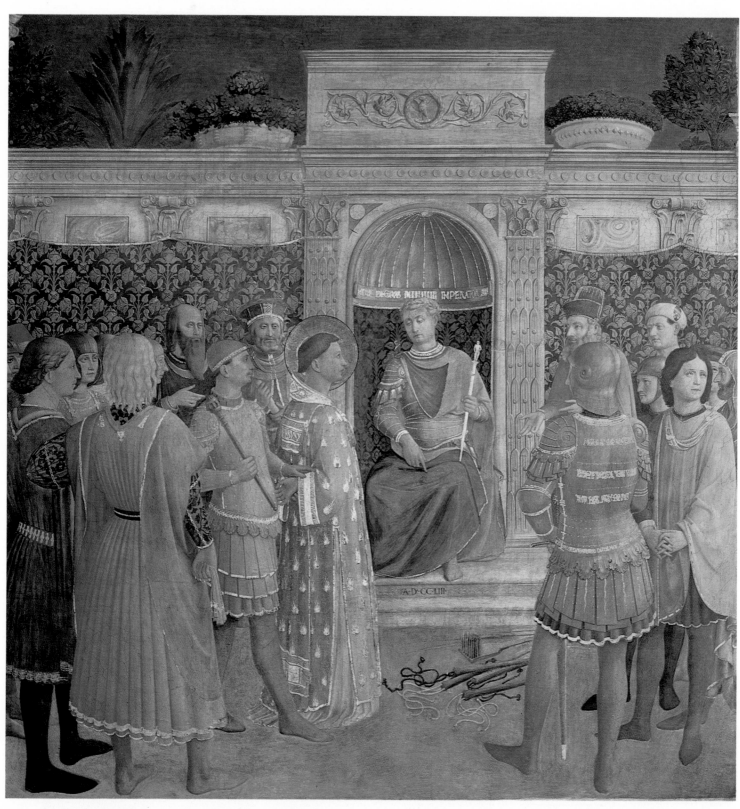

36. *St Lawrence before Valerianus* (left half of *St Lawrence before Valerianus and The Martyrdom of St Lawrence*). About 1447–8.
Vatican, Chapel of Pope Nicholas V

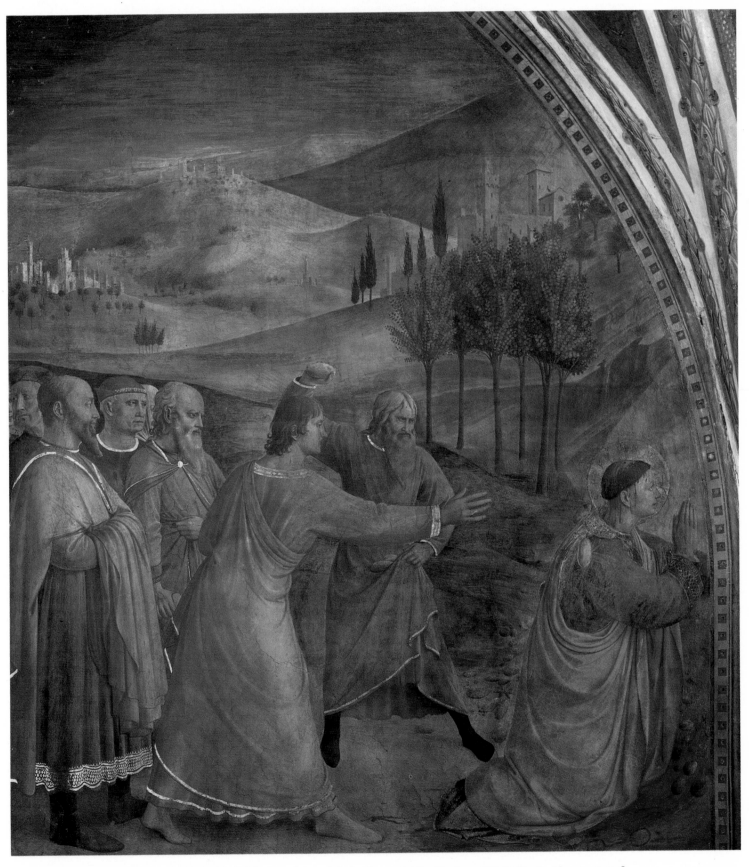

37. *The Stoning of St Stephen* (right half of *The Expulsion of St Stephen and The Stoning of St Stephen*). About 1447–8.
Vatican, Chapel of Pope Nicholas V

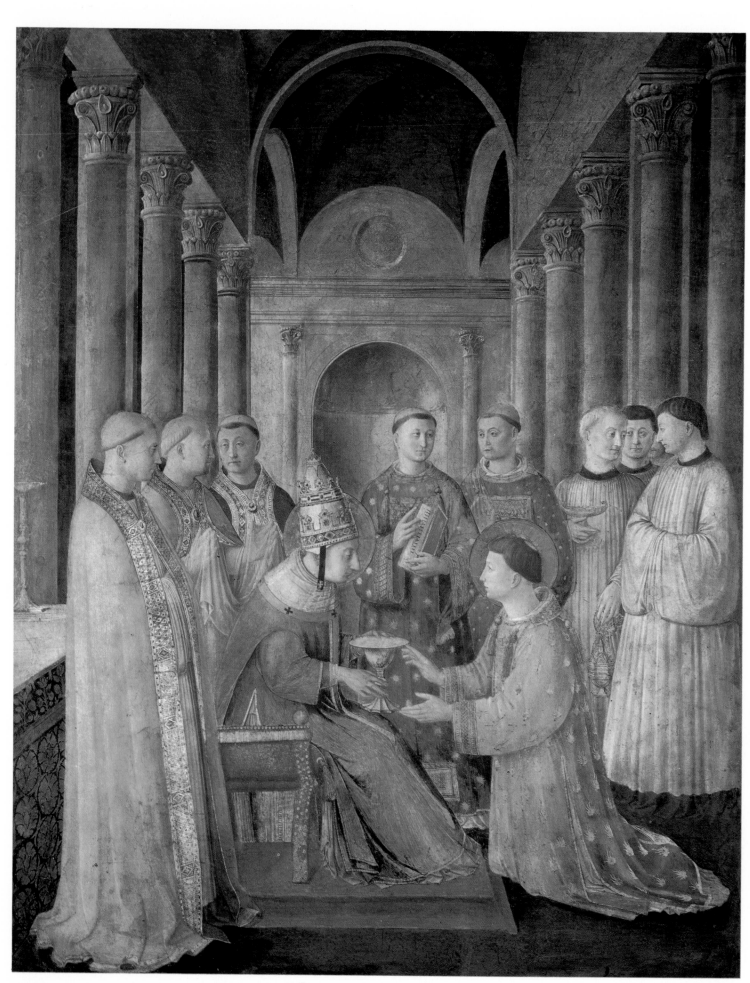

38. *The Ordination of St Lawrence*. About 1447–8.
Vatican, Chapel of Pope Nicholas V

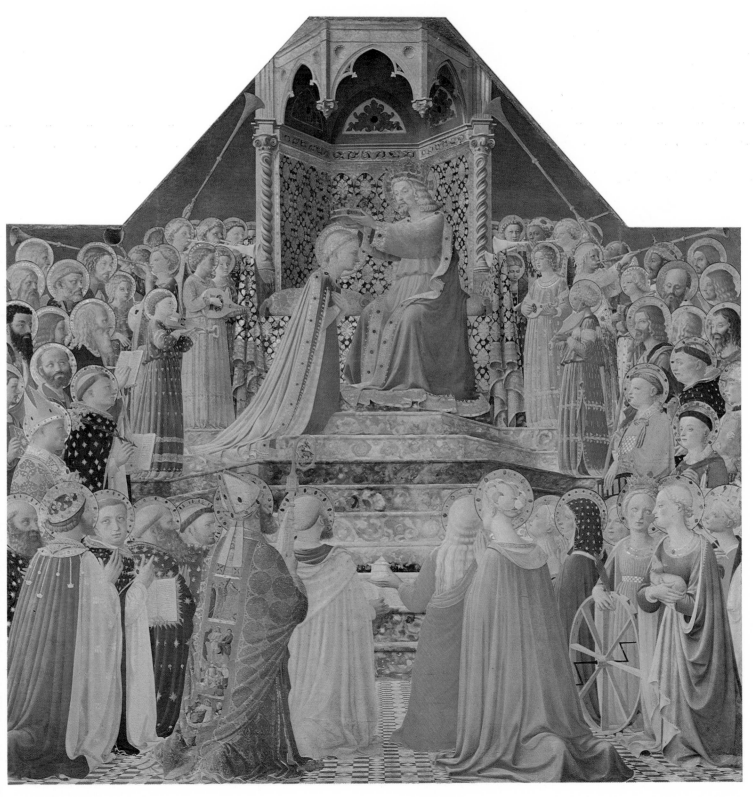

39. *The Coronation of the Virgin*. About 1450.
Paris, Louvre

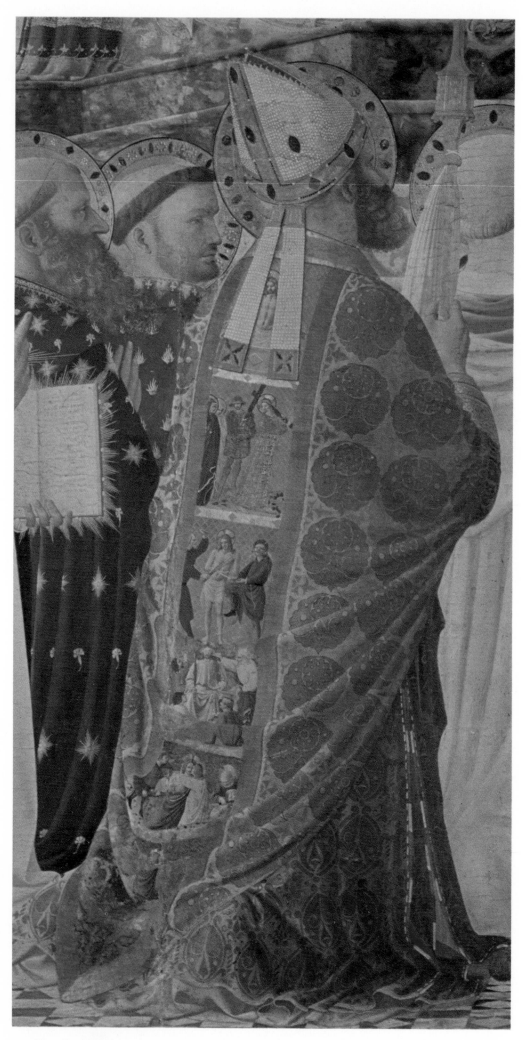

40. Detail of Plate 39

41. Detail of Plate 39

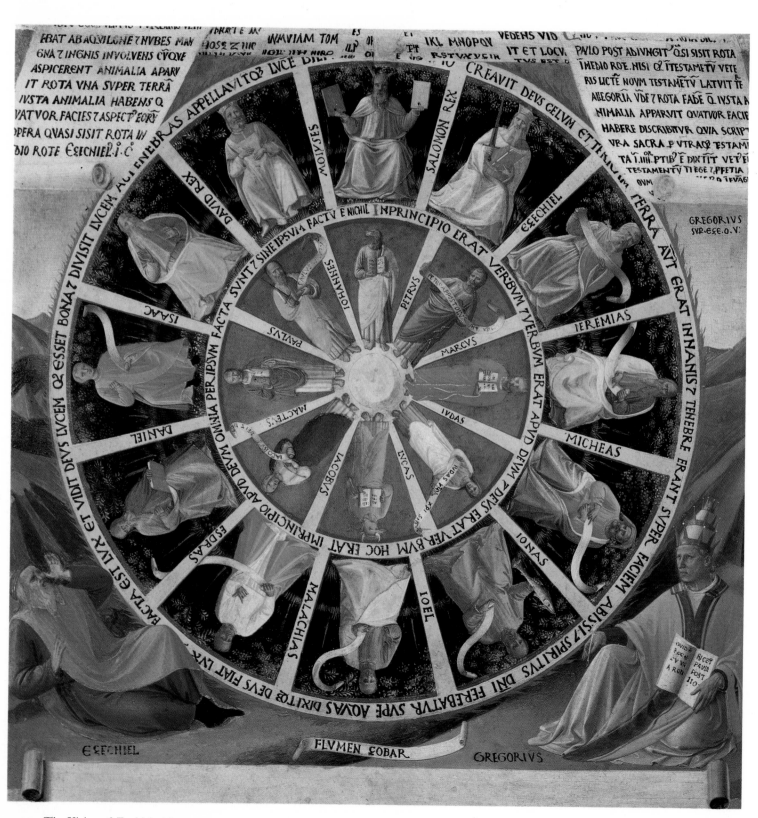

42. *The Vision of Ezekiel.* About 1451.
Florence, Museo di San Marco

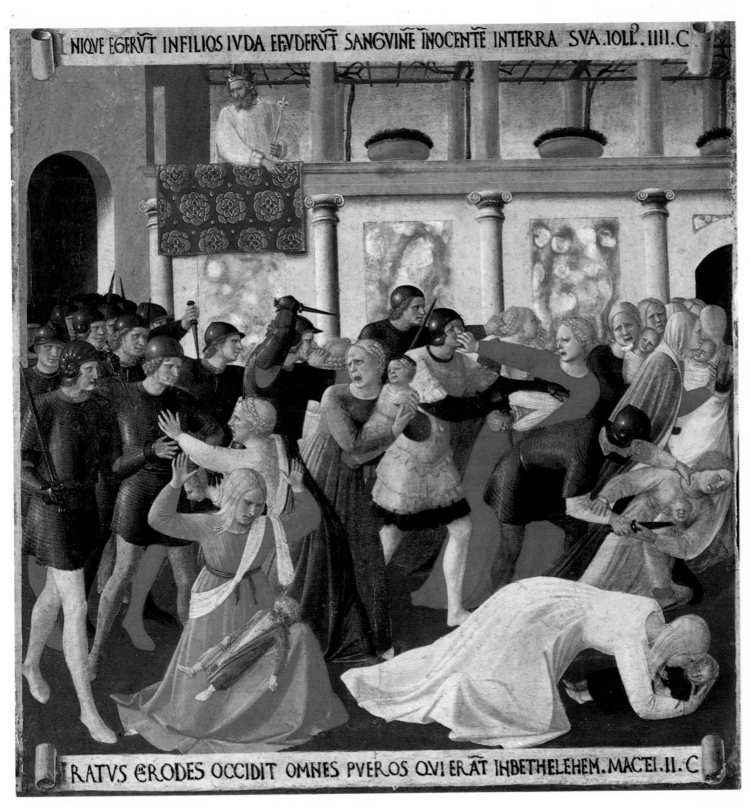

43. *The Massacre of the Innocents*. About 1451.
Florence, Museo di San Marco

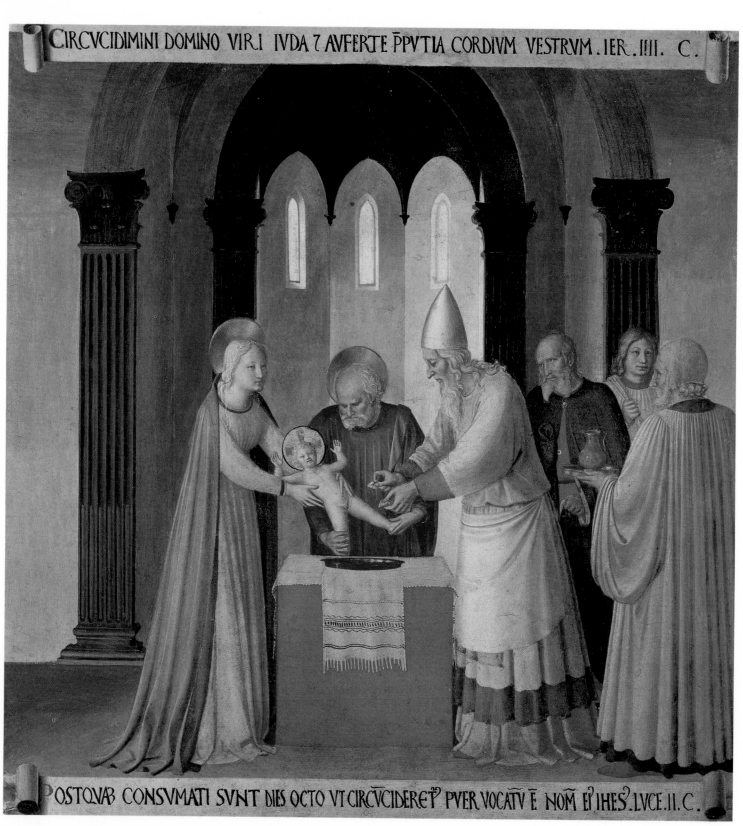

CIRCVCIDIMINI DOMINO VIR.I IVDA 7 AVFERTE ꝑPVTIA CORDIVM VESTRVM .IER .IIII. C

POSTQVAꝜ CONSVMATI SVNT DIES OCTO VT CIRCVCIDERETꝰ PVER VOCATV E NOM̃ EI̓ IHES.LVCE.II.C.

44. *The Circumcision*. About 1451.
Florence, Museo di San Marco

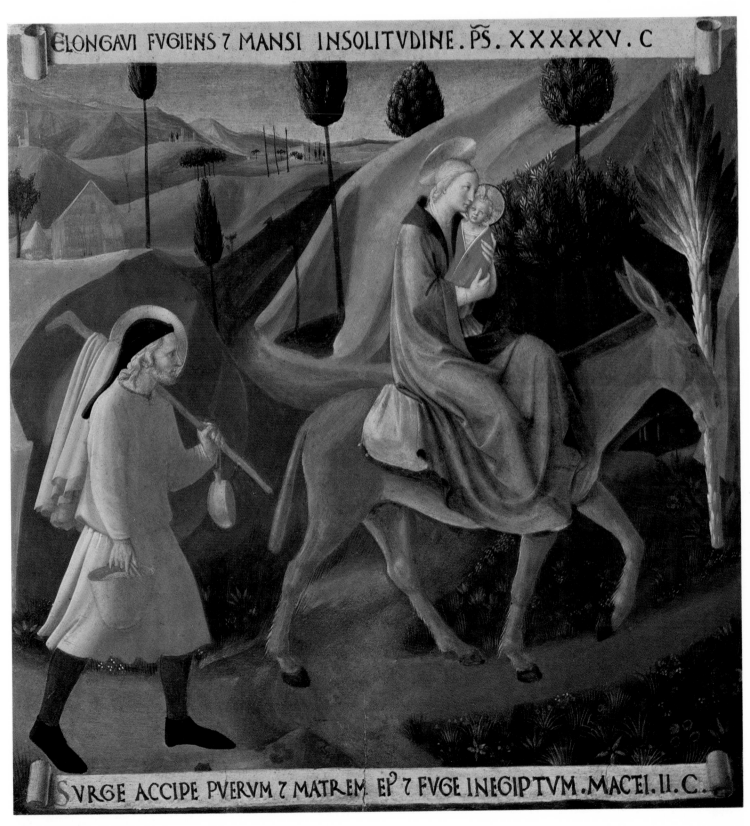

ELONGAVI FVGIENS 7 MANSI INSOLITVDINE. P̃S. XXXXXV. C

SVRGE ACCIPE PVERVM 7 MATREM EP 7 FVGE INEGIPTVM .MACEI. II. C .

45. *The Flight into Egypt.* About 1451.
Florence, Museo di San Marco

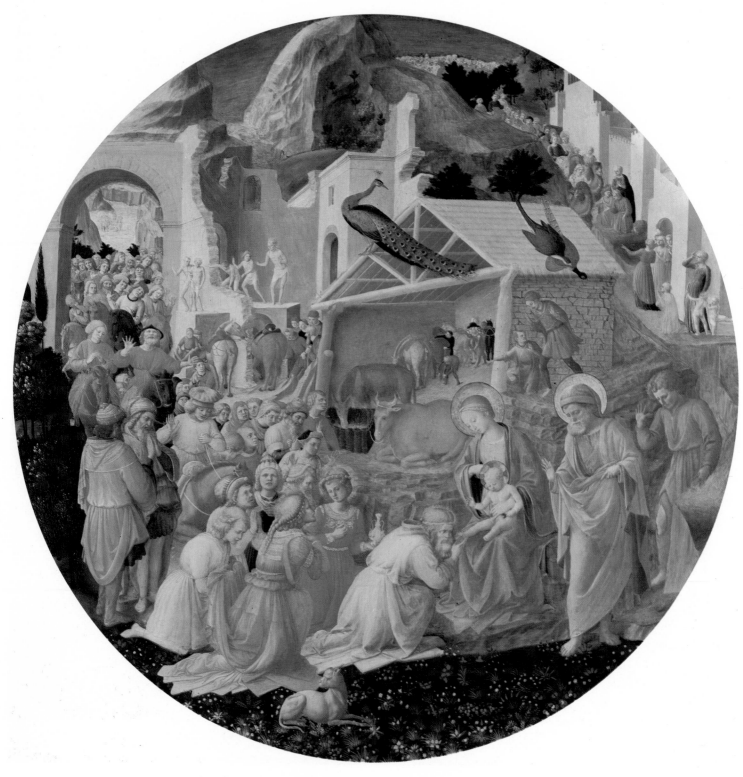

46. *The Adoration of the Magi* (with Filippo Lippi). About 1452-3.
Washington, National Gallery of Art (Kress Collection)

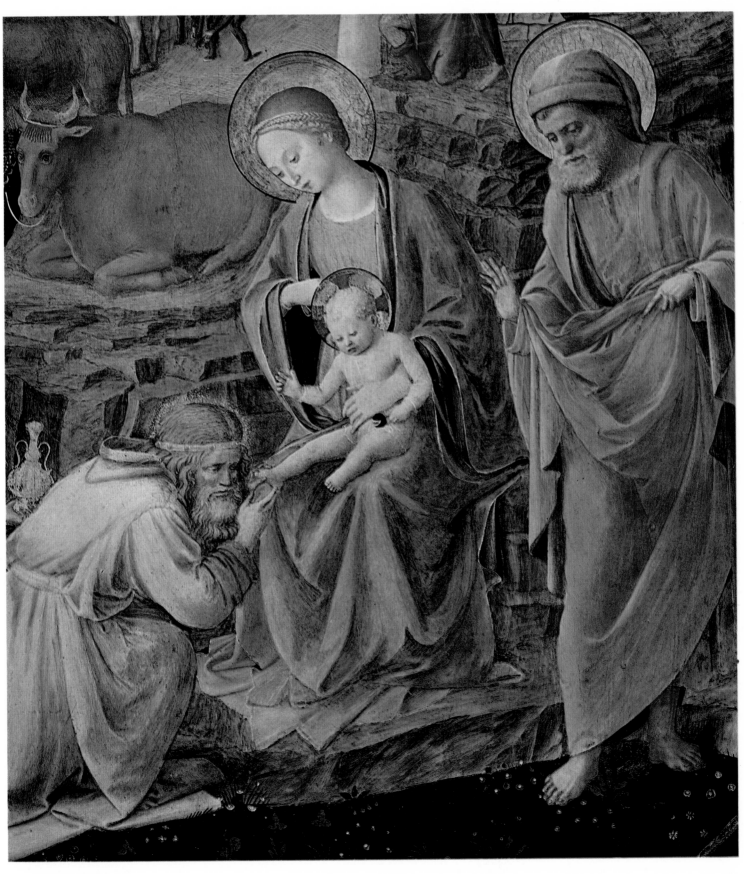

47. Detail of Plate 46

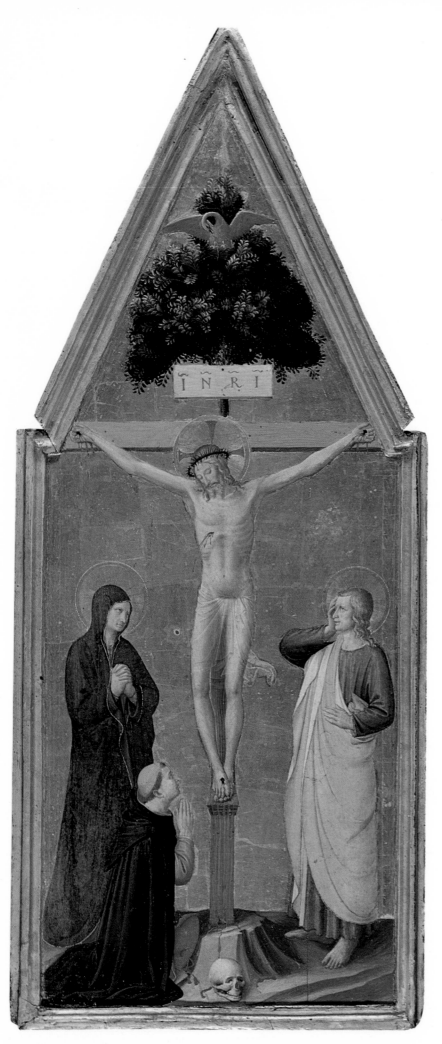

48. *Christ on the Cross with the Virgin and St John the Evangelist adored by a Dominican Cardinal.* About 1450–55. Cambridge (Massachusetts), Fogg Art Museum